Jenny Uglow

THE ILLUSTRATORS

Walter Crane

SERIES CONSULTANT QUENTIN BLAKE
SERIES EDITOR CLAUDIA ZEFF

117 ILLUSTRATIONS

Thames & Hudson

CONTRIBUTORS

Jenny Uglow has written acclaimed biographies of British 18th- and 19th-century writers and artists, including Elizabeth Gaskell, William Hogarth and Thomas Bewick. Her group biography of the Lunar Society won the James Tait Black Memorial Prize, and her life of Edward Lear the Hawthornden Prize for 2018. Uglow was editorial director of Chatto & Windus for many years and is a Vice President of the Royal Society of Literature.

Quentin Blake is one of Britain's most distinguished illustrators. For twenty years he taught at the Royal College of Art where he was head of the illustration department from 1978 to 1986. Blake received a knighthood in 2013 for his services to illustration and in 2014 was admitted to the Légion d'honneur in France.

Claudia Zeff is an art director who has commissioned illustration for book jackets, magazines and children's books over a number of years. She helped set up the House of Illustration with Quentin Blake where she is now Deputy Chair. Since 2011 she has worked as Creative Consultant to Quentin Blake.

FRONT COVER 'Here we go round the Mulberry bush' (detail), from *The Baby's Opera: A Book of Old Rhymes with New Dresses*, by Walter Crane. Frederick Warne and Co., 1877
BACK COVER Walter Crane, *Self-Portrait*, 1883. Courtesy the Whitworth, The University of Manchester

FRONTISPIECE Endpapers from 'An Alphabet of Old Friends', in *The Song of Sixpence Picture Book*, 1909
ABOVE Headpiece to 'The Rabbit's Bride', from *Household Stories from the Collection of the Brothers Grimm*, 1882
PAGE 112 Walter Crane's monogram signature

Walter Crane © 2019 Thames & Hudson Ltd, London
Text © 2019 Jenny Uglow

Designed by Therese Vandling

First published in 2019 in the United States of America by Thames & Hudson Inc., 500 Fifth Avenue, New York, New York 10110

www.thamesandhudsonusa.com

Library of Congress Control Number 2019932290

ISBN 978-0-500-02262-7

Printed and bound in China by C&C Offset Printing Co. Ltd

those days were the child's principal drawing materials, *pencil and slate.'*

Born in Liverpool on 15 August 1845, Walter was the third of five children. Three months after his birth, the family moved to Torquay, where he enjoyed a happy childhood apart from a disastrous spell at school under a brutal headmaster. He drew from the age of 6, colouring pictures from the *Illustrated London News* with his sisters, poring over William Harvey's engravings for the *Arabian Nights*, and the illustrations in the 1853 edition of Oliver Goldsmith's *Animated Nature* and Joseph Nash's *Mansions of England* (1839–49), and being captivated by the military prints in shop windows during the Crimean War. In the spring of 1857, when Walter was nearly 12, the Cranes moved to London. They lodged in Shepherd's Bush, looking out over brickfields making bricks for the new terraces in nearby Kensington and Notting Hill. Walter sketched the men laying bricks under straw to dry, and the sheds and horses. 'In fact,' he wrote in 'Notes on the Development of Artist Characteristics', for about two years 'my art schools were chiefly stables & cow sheds, varied by open commons'. His animal paintings were already admired locally and his picture of donkeys on a common was so good that it sold in a Knightsbridge shop for ten shillings, and his horses and dogs, mice and frogs have a life of their own in all his later illustrations.

As a boy visiting the London galleries he was awed by Benjamin Haydon's colossal canvases, 'full of energy, fiery rearing chargers and brass helmets', but most of all he admired J. M. W. Turner, a lifelong hero. Inspired by reading his father's copy of volume I of John Ruskin's *Modern Painters* (1843), he became fascinated by the sensational Pre-Raphaelite paintings. But he learned, too, from Albrecht Dürer's engravings at the 'Brompton Boilers', the South Kensington Museum (later the V&A), and from British wood-engravers like the great Thomas Bewick.

Ruskin's *Elements of Drawing* (1857) made him determined 'to draw trees with every leaf showing'. Soon he was illustrating poems, including a set of eighteen colour illustrations for Tennyson's 'The Lady of Shalott', with flowery borders and delicate watercolours of rivers and fields. This echoed the popular 'illuminated gift books'

OPPOSITE
Aladdin, or, The Wonderful Lamp,
1875

9

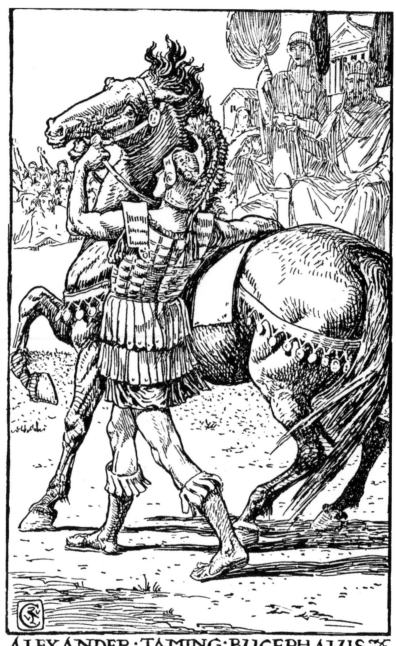

ALEXANDER·TAMING·BUCEPHALUS

ABOVE

The Children's Plutarch, 1910

OPPOSITE

'The Lady of Shalott', *c.* 1858

Willows whiten, aspens quiver,
Little breezes dusk and shiver
Thro' the wave that runs forever
By the island in the river

Flowing down to Camelot.

of the 1840s, one facet of the current Gothic revival, but they had a freshness and originality extraordinary in a boy of 13. A family friend showed them to Ruskin, who admired Crane's sense of colour, and to the engraver W. J. Linton, who immediately took Walter on as an apprentice draughtsman, without a premium.

Apprentice

In January 1859, Walter arrived at Linton's workshop in Essex Street, off Fleet Street. In his late forties, Linton was a leading wood-engraver, matched only by the Dalziel brothers and Joseph Swain of *Punch*. A passionate radical, a Chartist supporter and a friend of the exiled Mazzini in 1848, he published his own magazines, *The Cause of the People* and *The English Republic*. He was now married to his second wife, the novelist Eliza Lynn Linton, 'a strong-minded woman', Crane thought, 'full of advanced theories'. With his flowing hair and beard, odd clothes and huge black wide-awake hat, Linton, Crane wrote, was 'altogether a kindly, generous, impulsive and enthusiastic nature…a true socialist at heart, with an ardent love of liberty and with much of the revolutionary feeling of '48 about him'. He took Linton's radicalism to heart.

In the workshop there were six engravers and six apprentices, several of them deaf and dumb, communicating in rapid sign language, working by the window round a green-baize-covered bench. Here Crane learned to transfer drawings on to the boxwood blocks, using a hard pencil to make it crisp and clear, so that the engraver could cut away the block, leaving only the lines to be inked for printing. In his time off he played in the Temple gardens, watched barges on the Thames and wandered along Fleet Street to see the cartoons in the windows of *Punch*, especially those by John Leech, John Tenniel and Charles Keene.

In 1859, Linton fell on hard times and moved his firm back to their old premises at 85 Hatton Garden, where cats ranged the house-tops, and peacocks paraded on the parapets, 'and we could see the cock bird spread his gorgeous Byzantine half-dome of feathers', an image that

ABOVE
Study of a wood-engraver
at work, *c.* 1861

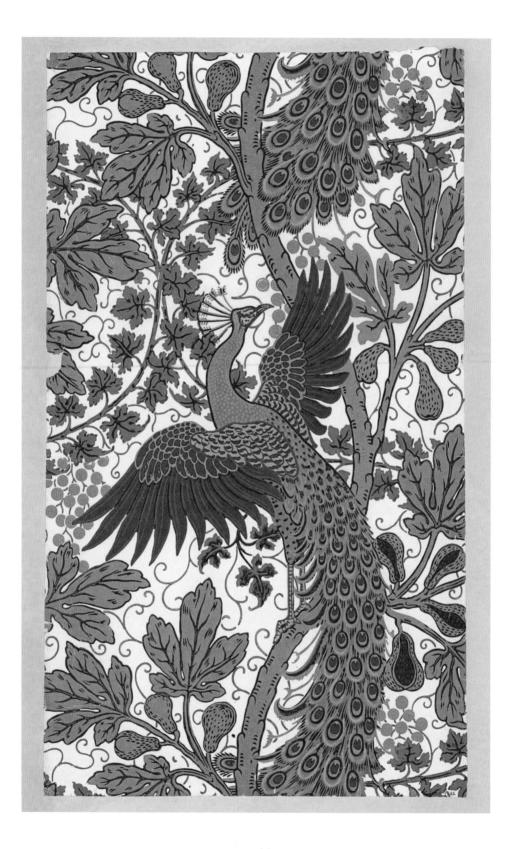

stayed with him always. Knowing Crane's skill at drawing animals, Linton got him a permit to sketch at the Zoo, a welcome change from his daily load: 'iron bedsteads for a certain catalogue for Messrs. Heals, medical dissections, tale cuts, Bible pictures, book illustrations'.

The Pre-Raphaelite magic

In January 1862, Walter's three-year apprenticeship ended. At 16, he was on his own, drawing illustrations for twopenny pamphlets and magazines and burying himself in the British Museum Reading Room to copy subjects for an Encyclopedia, 'from the bust of Shakespeare to the scenery of Honolulu'.

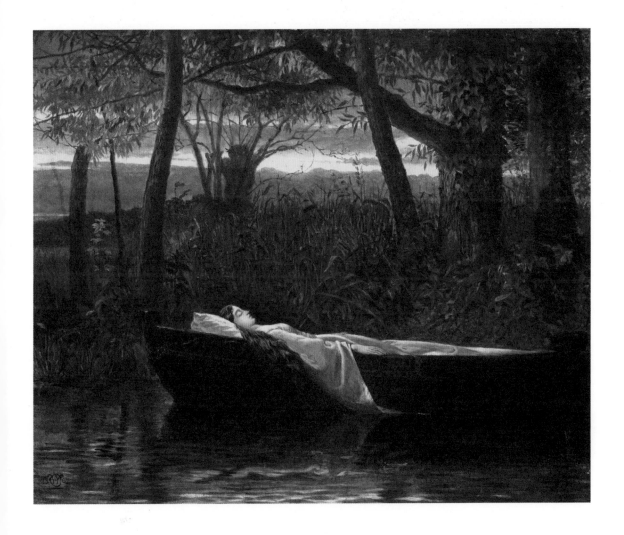

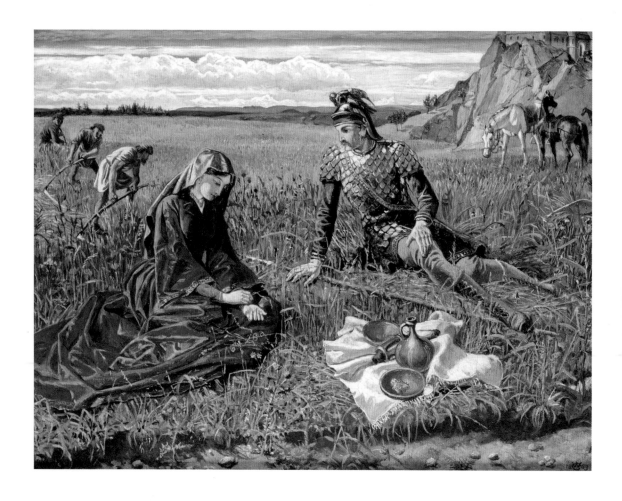

But, he wrote, 'My first love was painting'. He was entranced by the Pre-Raphaelite paintings at the International Exhibition of 1862 and that year his own oil of *The Lady of Shalott* was hung in the Royal Academy summer exhibition. The following year, perhaps inspired by illustrations he was drawing for Caroline Hadley's *Stories of Old: Bible Narratives for Young Children*, he painted *Ruth and Boaz* for Dr William Hood, the superintendent of Bedlam. Behind the couple among the reapers, the clouds are massing over a high – and very English – horizon, and the figures are more medieval than Biblical, reflecting Crane's love of costume. He was delighted when he was allowed to draw in the Armoury at the Tower of London, and Boaz's carefully painted armour anticipates the glorious trappings of many later knights.

ABOVE
Ruth and Boaz, 1863

John Everett Millais' *Sir Isumbras at the Ford* (1857) impressed him, he said, 'beyond words...It was strikingly original: it was romantic, and was a very forcible and truthful piece of painting, and in a manner quite fresh to my youthful eyes.' He saved up to buy the 1857 Moxon edition of Tennyson's *Poems*, with illustrations by Millais, William Holman Hunt and Dante Gabriel Rossetti, engraved by Linton and Dalziel, finding Rossetti's imagery, such as the crowned queens mourning the death of Arthur, 'entirely fascinating and practically inexhaustible'. Later Crane traced the revival of Decorative art to this group, who, he said, turned people's attention to other arts than painting by their love of detail, their intellectual analysis, their symbolism, naturalism, and sympathy with the poetic quality of medieval art.

In 1861, Linton was working on the tailpieces for Alexander Gilchrist's *Life of William Blake* (1863). Blake was another of Crane's heroes, but he was also 'seeking inspiration from the early Italians, Flemings, Medieval Illuminators, as well as the modern pre-raphaelites', and bought photographs of Dürer's 'immortal' prints of 'Knight and Death' and 'Melancolia', and 'Death the Friend' and

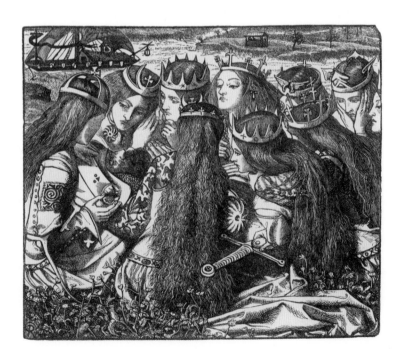

RIGHT
Dante Gabriel Rossetti,
The Weeping Queens, 1857

'Death the Enemy' by Alfred Rethel, one of the German Nazarene artists admired by the Pre-Raphaelites, whose vigorous line had a great influence on Crane's style.

In the mid-1860s he was moved by the conviction of Ford Madox Brown's great painting *Work*, a scene of navvies digging a trench in a Hampstead road. But it was seeing the watercolours of Edward Burne-Jones at his debut show at the Old Water-Colour Society in 1864, that really showed him what an artist could do:

> *The curtain had been lifted, and we had had a glimpse into a magic world of romance and pictured poetry, peopled with ghosts of 'ladies dead and lovely knights' – a twilight world of dark mysterious woodlands, haunted streams, meads of deep green starred with burning flowers, veiled in a dim and mystic light, and stained with low-toned crimson and gold, as if indeed one had gazed through the glass of*
>
> > *Magic casements opening on the foam*
> > *Of perilous seas in faerylands folorn*

It was, perhaps, not to be wondered at that, fired with such visions, certain young students should desire to explore further for themselves.

When Crane came to illustrate his children's books, he borrowed Pre-Raphaelite poses, costumes and devices. In particular, he noted Burne-Jones's use of the languid gesture, the floating robes, the symbolic detail and use of a window, or a tapestry behind the main figure, to deepen the implications of the story.

After the Dudley Gallery – the home of 'poetic', 'peculiar' art, according to critics – held its first spring watercolour show in 1865, Crane became an annual exhibitor. Several of his watercolours were escapist idylls of a pre-industrial past and one, shown in 1868, took its title from John Milton's 'L'Allegro', 'Such sights as youthful poets dream/On summer eves by haunted stream'. His work would encapsulate this dream.

Like Burne-Jones, Crane painted classical as well as Gothic themes, and he was also influenced by Blake's fluid

forms. Beginning with his portrayal of the battle of good and evil against the river of time, in the Persian legend *Ormuzd and Ahriman* (1869), his paintings became increasingly allegorical.

The black-and-white sixties

Crane's early illustrative work was in black and white. He first caught the critics' eye with his illustrations for John R. de Capel Wise's *The New Forest: Its History and its Scenery*. He spent the summer of 1862 sketching in the forest, before transferring his drawings to the block for the engravers. His scenes won warm praise, notably in the *Cornhill* from George Henry Lewes, who foretold a glowing future for the 'very young artist of only seventeen', and he became a close friend.

This was a boom time for illustrators, working especially for the new magazines, founded almost annually: *Once a Week*, with Charles Dickens as editor, 1859; the *Cornhill* and *Good Words*, 1860; *Fun*, 1861; *London Society*, 1862. Breaking from the comic satirical style of William Hogarth and George Cruikshank, the illustrators of 'the Sixties' were serious, often sentimental, sure of the importance of their work, with a classical feeling for the body and the value of naturalism but also a belief in the symbolic power and language of art.

Crane joined Millais, George du Maurier and Frederick Sandys in drawing for *Once a Week*, where his illustrations showed how well he could handle narrative suspense. But he was still searching for his own style. To begin with, Cruikshank and Phiz lurked behind his comic pictures, fashion catalogues behind his elegant scenes for *London Society* (where his animal sketches also paid off in an article on 'Dickens's Dogs'), the lyrical style of Frederic Leighton, who was illustrating George Eliot's *Romola* in the *Cornhill* in 1863, behind his domestic scenes. He took notice, too, of the gift for fantasy of Arthur Hughes, the most eerie black-and-white illustrator for children.

Work piled up: Leighton-like plates for F. G. Trafford's novel *The Moors and the Fens* in 1863; drawings, engraved

by Linton, for *The Month* in 1864–65; illustrations for
Victorian nursery staples, Thomas Day's *History of Sandford
and Merton* and John Aikin and Mrs Barbauld's *Evenings
at Home*; characterful pictures for Nathaniel Hawthorne's
Transformation, or, The Romance of Monte Beni (the
English title for *The Marble Faun*) in 1865. After a holiday
in Paris with his brother Tom, in July 1866 he published
an illustration in *Punch*, *Great Show of Chignons: A Hint
for the Hairdressers' Society*. A fresh step came in 1869 with
his work on the Gothic fantasies of *King Gab's Story Bag*
by Charles Marshall, writing as 'Heraclitus Grey'. With the
first use of his Crane monogram, the book was advertised
as having 'Illustrations after Albert Dürer' – a triumph of
black and white.

Time off

Throughout the 1860s Crane spent long summers in the
Peak District. He went there first with John R. Wise, who was
planning a book on the region. Later he lodged at Hazelford
Hall, near Hathersage, with his brothers Tom and Arthur, his
sister Lucy, and his great friend Harry Ellis Wooldridge. He
loved the deep valley and craggy moors, painted landscapes
and cloud studies, and read voraciously. He still devoured
everything by Ruskin, but Wise introduced him to Herbert
Spencer, J. S. Mill and Ralph Waldo Emerson, and he became
intrigued by the developmental ideas of Auguste Comte, and
the evolutionary theories of Charles Darwin and Spencer.

He worked hard, but there was time for fun. His Hazelford
sketchbooks were full of jokes about Wooldridge's music, and
comic sketches of playing croquet on sloping grounds, good
meals, picnics in the sun.

OPPOSITE

Frontispiece, *King Gab's Story Bag*,
1869

BELOW

Crane's drawing of himself at work
in his room at Hazelford Hall,
Derbyshire, 1865

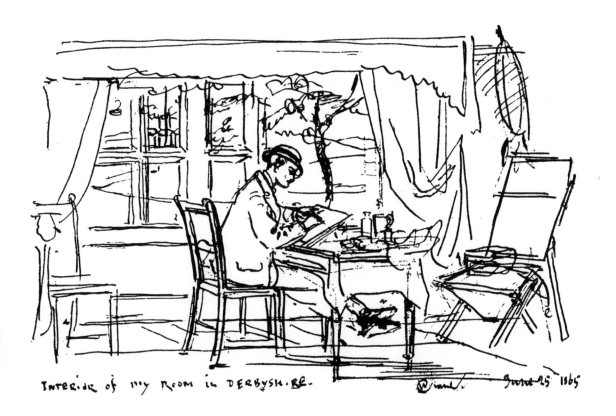

INTERIOR of my Room in DERBYSHIRE.

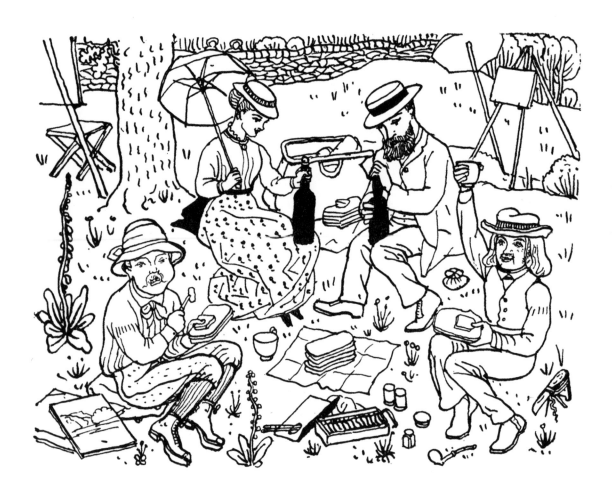

In 1868, Crane met Mary Frances Andrews, daughter
of an Essex squire, and soon began writing sonnets to 'the
absent beloved one'. They became engaged in the spring of
1870. Late that summer Crane joined her family in Ambleside,
and they were married the following year, on 6 September.

on the characters and groups, the line and mass of the page. Then he simplified the composition, giving firm outlines to the shapes and the background – rather like the outlines for stained glass. The drawing was then made on tracing paper, so that Evans could use it in reverse to draw the picture on the block. Once the outline was done, the 'key' was printed. Crane painted the proof in watercolours so that Evans could work out how to print the colour. Each colour needed a separate block, and these were printed in sequence, gaining subtle, rich results from overlaying one colour on another. Finally the key was printed over the coloured page, and the text was set from metal type.

The illustrations fell roughly into two types, one showing scenes from contemporary life, the other from stories and

ABOVE
Drawing for *Jack and the Beanstalk*, 1875

OPPOSITE
Partial watercolour for *This Little Pig went to Market*, 1871

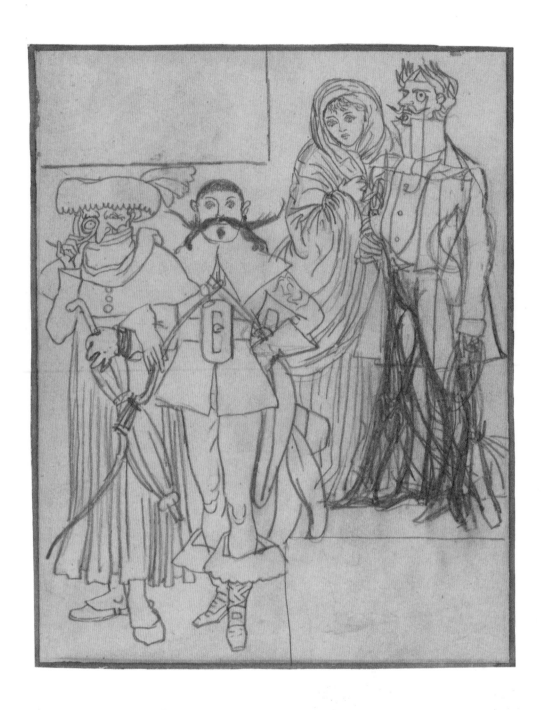

Drawing for *King Luckieboy's Party*

King Luckieboy's Party, 1870

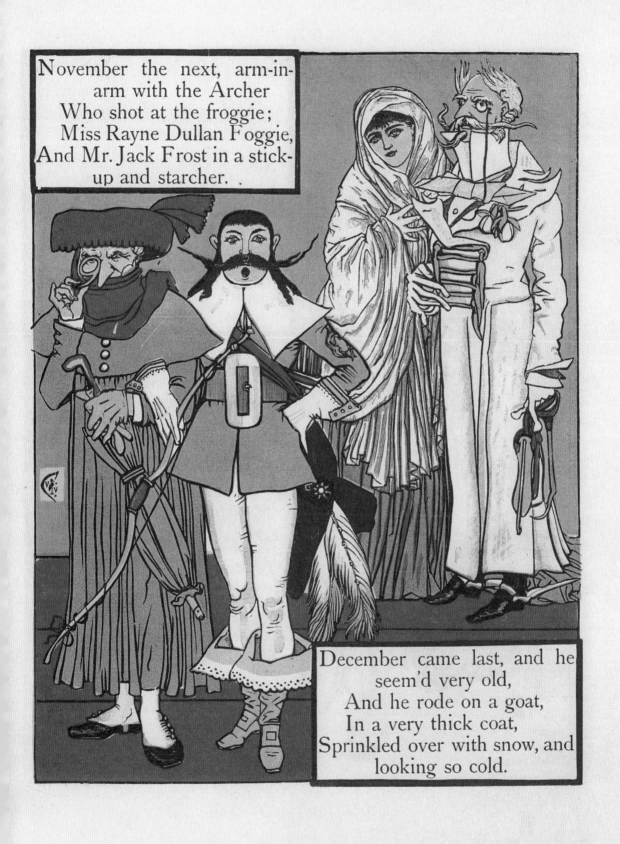

November the next, arm-in-
 arm with the Archer
Who shot at the froggie;
Miss Rayne Dullan Foggie,
And Mr. Jack Frost in a stick-
 up and starcher.

December came last, and he
 seem'd very old,
And he rode on a goat,
In a very thick coat,
Sprinkled over with snow, and
 looking so cold.

ADJECTIVES tell the kind of Noun,
As 'great,' 'small,' 'pretty,' 'white,' or 'brown.'

ix Joiners in Joiner's Hall,
Working with their tools and all.
Five beetles against the wall,
Close to an old woman's apple-stall.
Four puppies with our dog Ball,
Who daily for their breakfast call.
Three monkeys tied to a log.
Two puddings' ends, would choke a dog,
Or a gaping, wide-mouthed, waddling frog.

OPPOSITE

Sing a Song of Sixpence, 1866,
redrawn 1909

ABOVE

*A Gaping-Wide-Mouth-Waddling
Frog,* 1866

himself. He filled the page, making the text-frame a witty part of the design. He gave the animals in *This Little Pig went to Market* unnervingly eccentric dress, and in *King Luckieboy's Party*, another of his own stories, he created a quaint procession of the months and the zodiac.

Routledge virtually took over the Toy Book publishing in 1866 and Crane would draw many books for them in

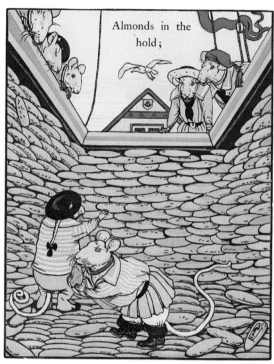

the next decade: altogether he designed over forty books,
printed in many thousands. Early in this work, a naval
friend lent Crane a book of Japanese prints by the master
Utagawa Toyokuni, and he found the ideal model in their
'clear black outlines, flat brilliant colours, and dramatic as
well as decorative feeling'. He liked the way that the 'ukiyo-e'
technique, 'portraits of the floating world', caught life as
it passed. The impact of this showed in 1869 in *One, Two,
Buckle My Shoe*, in his bold design and crisp accents, the
details of fan and fire-screen and ebonized chairs linking
his interest in the style with the current English taste for
all things Japanese.

The Japanese influence – so powerful for many painters
and decorators – is seen at its subtle best in the lovely
Fairy Ship of 1870, full of entertaining illustrations of the
duck as captain and his crew of eager mice. In the simplest
designs, like the almonds in the hold, Crane showed that
he could use the rhythm of his lines to create unusual,
astonishing effects.

ABOVE LEFT
One, Two, Buckle My Shoe, 1869

ABOVE RIGHT
The Fairy Ship, 1870

Beauty and feeling

After their marriage in 1871, Crane and Mary journeyed down the Rhine and spent two years in Italy, visiting Venice, Florence, Naples and Capri, and settling happily in a noisy Rome apartment. He still worked on the Toy Books, posting drawings back to Evans in London, who sent the proofs back to Rome for colouring. By now Evans was using photography to transfer Crane's drawings to the block, a step towards photographic block-making, 'photogravure', developed in the late 1870s.

The success of the Toy Books prompted Routledge to make composite volumes, binding two or three titles together and in 1873, when Crane returned to London, they began a sixpenny 'New Series of Walter Crane's Toy Books'. The next year they launched the larger 'Shilling Series', using a lavish six colours, with the text on separate pages. Each series had a standard cover design, the sixpenny series showing a crane and the shilling books a child reaching for stories like fruit. To keep prices low, print runs were huge, with a first run of 10,000 copies.

As he worked, Crane's inventiveness grew. He added details to catch the eye and showed the flow of the story by small background scenes of what had gone before, such as the cobbler behind Goody Two Shoes proudly trying on her new shoes. His use of verticals and different scales and perspective gave his scenes a powerful energy. His

BELOW LEFT AND RIGHT
'A Quiet Apartment', drawings from the Cranes' time in Italy in the early 1870s

BETWEEN DECKS DURING AN ACTION ~ OR THOSE PEOPLE AGAIN

OUR CONJECTURES OF THE FAMILY ABOVE & THEIR OCCUPATIONS

PRICE·SIXPENCE; or Mounted on Linen. ONE SHILLING.

WALTER CRANE'S TOY BOOKS

NEW SERIES

·BABY'S·OWN·
ALPHABET·

THIS LITTLE PIG WENT

KING LUCKIE BOY

YE FAIRY

PUFFY

JACK

HOW JESSIE WAS LOST

ABC

✻ GEORGE·ROUTLEDGE & SONS ✻

They rushed upstairs, and Father Bruin,
 growling.
Cried out, "Who's lain upon my bed?"
"Who's lair. on mine?" cried Mother
 Bruin, howling;

"No, Master," said Puss, "give me boots to my
feet—
A pair of top-boots—and please leave me alive,
And you shall just see how we'll flourish and
thrive."

Crane's firm lines and flat colours were tailored to his audience. 'Children,' he wrote later, 'like the ancient Egyptians, appear to see most things in profile, and like definite statement in design. They prefer well-defined forms and bright frank colour. They don't want to bother about three dimensions. They can accept symbolic representations.' Children used drawing, he thought, 'as a kind of picture writing, and eagerly follow a pictured story'. What was more, 'when they can count they can check your quantities, so that the artist must be careful to deliver'. Only precisely twenty-four blackbirds would do for 'Sing a Song of Sixpence' – not twenty-two or twenty-five. And both artist and audience could be free to dream:

> The best of designing for children is that the imagination and fancy may be let loose and roam freely, and there is always room for humour and even pathos, sure of being followed by that ever-living sense of wonder and romance in the child heart – a heart which in some cases, happily, never grows up or grows old.

This was an interesting moment in the history of Victorian children's literature, when writers began to identify with the minds of children, as opposed to talking down. Crane understood their intensity, the way they would pore over a page, finding the skull and crossbones on a giant's chair, noticing the bats on the wall, or Cinderella's discarded boots. They relished powerful and strange images: the sensuous Orient of *Ali Baba*, the Japanese oddities of *The Frog Prince*, or monstrous turkeys for his samurai-villain in *The Yellow Dwarf*. Most importantly, Crane's illustrations never lost their humanity. We see this in the expression on the sailor's face as he looks down at the sleeping infants in *Princess Belle-Etoile*, while porpoises leap and a crescent moon hangs low. And in Beauty's concern as she bends over the agonized form of the Beast. Crane was a great illustrator because he was a true storyteller, uncovering genuine emotions beneath the fantasy – rage, malice and envy; grief and longing; tenderness, kindness and love.

OPPOSITE
Bluebeard, 1875

OVERLEAF
Jack and the Beanstalk, 1875

PAGE 50
Valentine and Orson, 1874

PAGE 51
Cinderella, 1873

On he went, and reached ⸺
 ɪot at home;
Wife permitted Jack to eɪ⸺
Meat and drink she gave ⸺
 house,
And at last she hid him, ⸺
 spouse,
Who, on entering, loudly ⸺
 meat,
But was by his wife persu⸺
(Grieved I am that it con⸺
And when he his supper ⸺
 hen,
Who a golden egg prod⸺
 "Lay!"
When the giant fell asleep ⸺

se, and found him

so far he 'd come ;

ed him over all the

the hunger of her

plainly smelt fresh

s meal to eat,
the flesh of men);

brought a splendid

the giant shouted

hen and ran away.

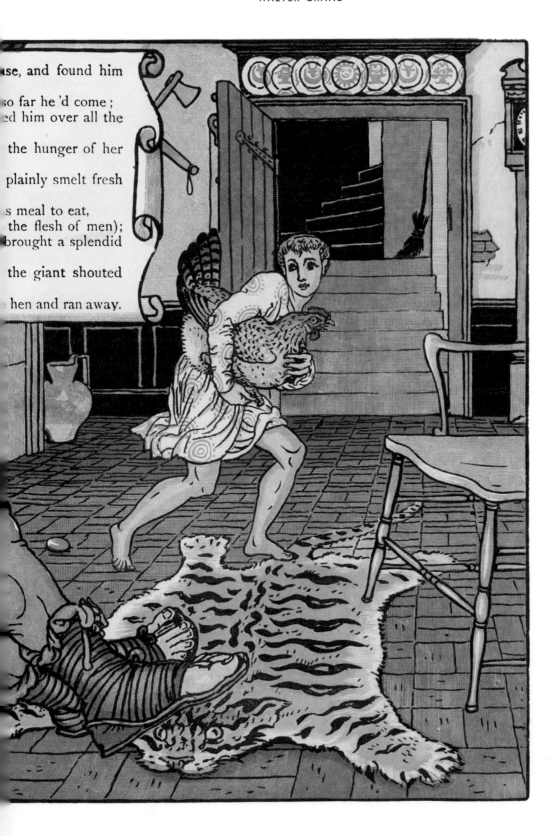

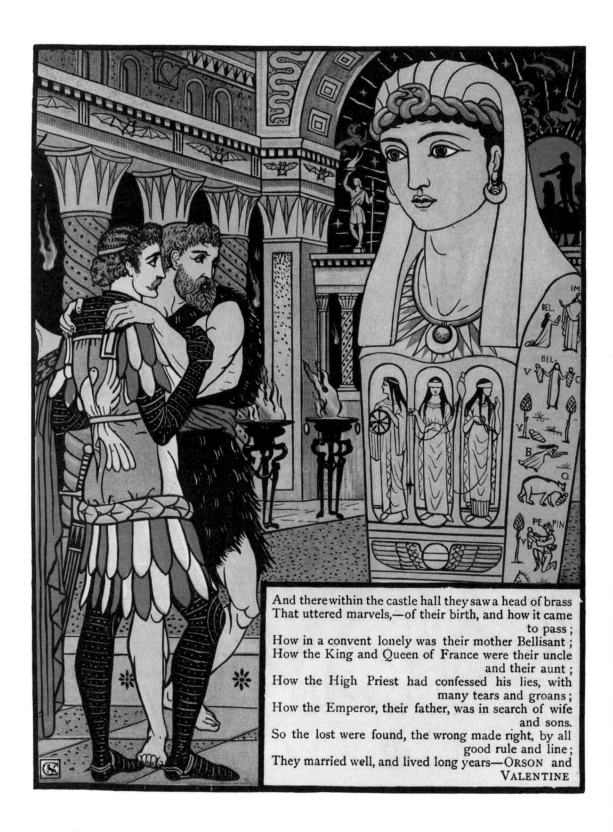

And there within the castle hall they saw a head of brass
That uttered marvels,—of their birth, and how it came
to pass;
How in a convent lonely was their mother Bellisant;
How the King and Queen of France were their uncle
and their aunt;
How the High Priest had confessed his lies, with
many tears and groans;
How the Emperor, their father, was in search of wife
and sons.
So the lost were found, the wrong made right, by all
good rule and line;
They married well, and lived long years—ORSON and
VALENTINE

ideal was to live in intense appreciation, as Walter Pater urged in the Conclusion to his *Studies in the History of the Renaissance* of 1868: 'to burn always with this hard, gemlike flame, to maintain this ecstasy'. Crane never held entirely to this idea of 'Art for Art's Sake', but he did accept Pater's view that understanding the art and myths of the past could help people defy the brutal, commercial present. Critics used the term 'Decorative' dismissively, linking it to triviality, elaboration, excess and effeminacy. But to Crane 'decorative' was an ideal. While 'pictorial' art, he repeated insistently, merely copied reality, decorative art was expressive, suggestive, 'poetic' and 'abstract'. Line, he wrote, is 'a language, a most sensitive and vigorous speech of many dialects; which can adapt itself to all purposes', and images and symbols could convey ideas through direct appeal to the eye. Even the letters of the alphabet were once pictures, growing into abstraction until they reached the familiar marks of today.

On another plane, a decorative environment could transform the way adults lived. Writing later about design, Crane revealed his own idealistic quest. The search for beauty, he concluded, was 'the purely inspiring artistic purpose'. Technical skill could give 'character' but *'beauty is not so easy to command'*:

> *It is so delicate a quality, so complex in its elements, a question often of such nice balance and judgment – depending perhaps upon a hair's-breadth difference in the poise of a mass here, or the sweep of a curve there – that we cannot weave technical nets fine enough to catch so sensitive a butterfly. She is indeed a Psyche in art, both seeking and sought, to be finally won only by devotion and love.*

In his *Beauty and the Beast*, the beast appears first as a great boar, a dandified soldier and consummate consumer, eyeing his possessions through his monocle. But the delicacy of his surroundings (including a tiny classical scene on the harpsichord showing Orpheus with his lyre taming the beasts), suggest a deeper response. Beauty – the Psyche, or soul of art – can awaken and inspire a new kind of life.

OVERLEAF
Beauty and the Beast, 1874

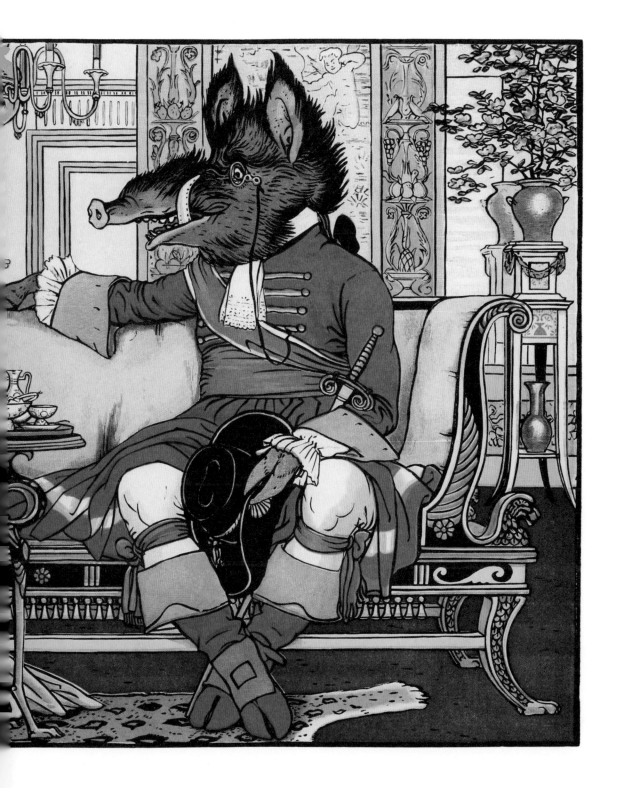

Design

'Ornamental effect and details have always had great fascination for me,' Crane wrote, explaining that his illustrations had led to many commissions in applied decoration, 'such as wallpapers, frieze, needlework, tapestry, tiles, mosaic and stained glass.'

In the late 1860s, George Howard, a painter and the future 9th Earl of Carlisle, saw his paintings and introduced him to Burne-Jones, William Morris and their circle, and a few years later, in 1875, Crane was called in to complete Burne-Jones's frieze of Cupid and Psyche for Howard's new house, designed by Philip Webb, at 1 Palace Green. An earlier design highlight was his ceiling and frieze, silvered and tinted with coloured lacquers, and other fine details for the dining room of Alexander Ionides at 1 Holland Park, a house that became a showcase for decorative art. As his reputation spread his many designs included mosaics for Frederic Leighton's Arab Hall, and schemes for William Spottiswoode's Combe Bank, where the ceiling of the saloon bore 'ornamental figures of the planets and the seasons, in gesso relief, gilt and silvered, in various tones'. A fashionable designer, he became part of the Holland House set, with G. F. Watts, Frederic Leighton, Val Prinsep, Burne-Jones and James Abbott McNeill Whistler, and his house was full of artists and writers.

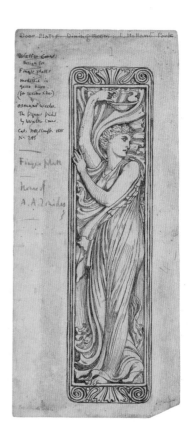

The irony was, of course, that Crane's design work, like that of Burne-Jones and Morris, who also turned to craft with an ideal of transforming social life, could be afforded only by the rich. But Crane's illustrations also appealed to progressive manufacturers, thus reaching a wider middle-class market, though rarely the homes of the working poor. He designed pots for Wedgwood, and tiles for Maw and Co. and later for Pilkington's, like the 'Nox' tile, for the Paris exhibition of 1878. He made designs for embroidery, textiles and carpets, and over the years created more than fifty wallpapers for Jeffrey and Co., ranging from papers for the nursery – an entirely new idea – to beautiful swirls and arabesques of flowers and birds for grand salons.

Thinking carefully of each room, Crane worked in harmonizing colours, with different papers below and above the dado and a frieze near the ceiling. He designed carpets

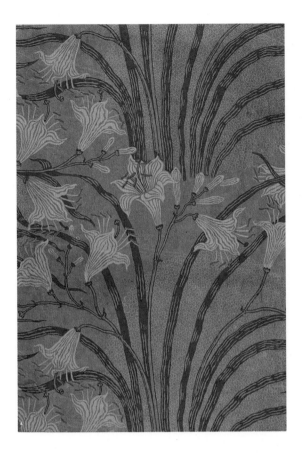

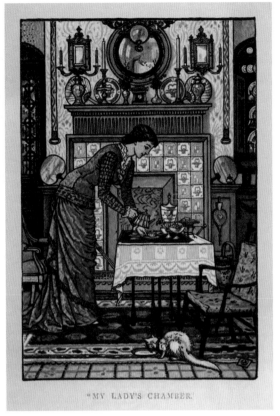

"MY LADY'S CHAMBER."

balance and pattern. Design work and illustration constantly overlapped. The delightful endpapers for his alphabets are as formal as any of his wallpapers. In *The Absurd ABC*, the vertical panels, with letters above and text below, combined pattern with energy and grotesque comic drama. Conversely, in the *Baby's Own Alphabet*, a combination of vertical and horizontal allowed the letters to work as stories.

Later he outlined his thinking in lectures published as *The Bases of Design* (1898) and *Line and Form* (1900). He took students through the different stages: the blocking out of shapes, the importance of outline, the expression of emotion through gesture, the relation of text to ornament, the way that different scales of direction can draw in the eye and create movement. Everything he wrote could be applied to his illustrative work: a confidence in design, combined with a feeling of romance and a great sense of fun, was one secret of his great appeal.

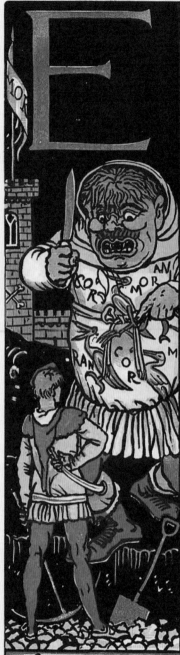

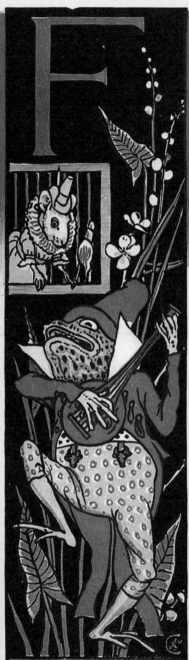

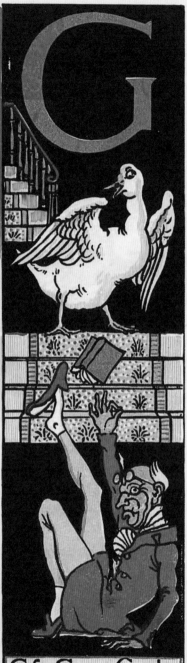

E for the Englishman,
ready to make fast
The giant who wanted to
have him for breakfast.

F for the Frog in the story,
you know,
Begun with a wooing but
ending in woe.

G for Goosey Gander,
who wandered upstairs,
And met the old man
who objected to prayers.

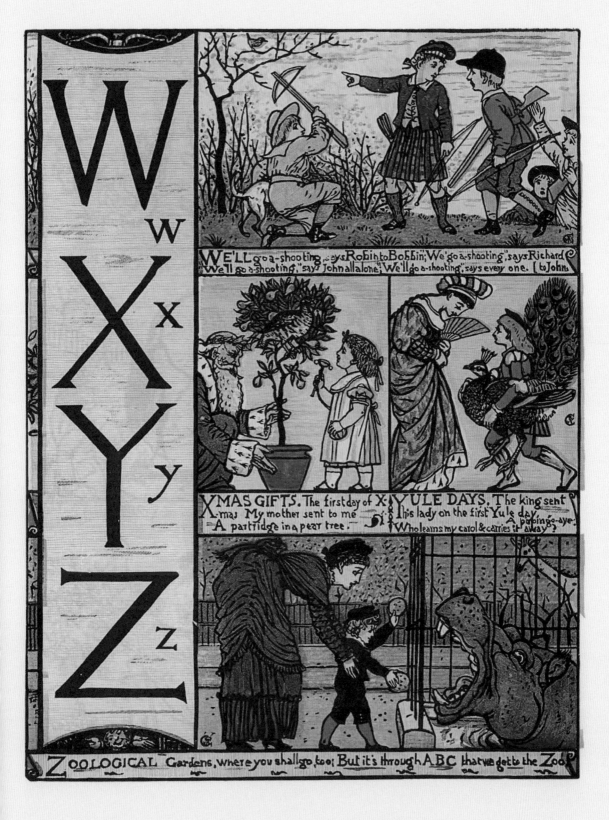

W w
X x
Y y
Z z

WE'LL go a-shooting, says Robin to Bobbin; We'go a-shooting, says Richard
We'll go a-shooting, says John all alone; We'll go a-shooting, says every one. [to John.

XMAS GIFTS. The first day of X- YULE DAYS. The king sent
mas My mother sent to me his lady on the first Yule day
A partridge in a pear tree. Who learns my carol & carries it away?

ZOOLOGICAL Gardens, where you shall go too; But it's through ABC that we get to the Zoo.

Operas and songs

In 1875, Crane parted company with Routledge when they refused to give him a royalty in his new contract. In his place as Toy Book illustrators, Evans found two coming stars, Randolph Caldecott and Kate Greenaway: to Crane's dismay, his designs for valentine cards were published with Greenaway's in *A Quiver of Love*, in 1876. These, and occasional cards for Christmas and Easter, were produced by Marcus Ward, where his brother Tom soon became Art Director.

Moving to Warne & Co. in 1876, Crane drew the small, square *The Baby's Opera: A Book of Old Rhymes with New Dresses*, inspired by the square tiles he had been designing for Maw and Co. The tunes were arranged by his sister Lucy, and the book's fifty-six pages, engraved and printed by Evans, were coloured throughout in subtle blues, greens and pinks. Booksellers shook their head but the public loved it: the first edition of 10,000 sold out at once, and in the next two decades *The Baby's Opera* sold 50,000 copies. To follow it, in 1878, Walter and Lucy created *The Baby's Bouquêt*, with more songs and charming pictures. (The writer Penelope Fitzgerald shrewdly pointed out that Crane's *Round the*

BELOW LEFT AND RIGHT

The Baby's Opera, 1877

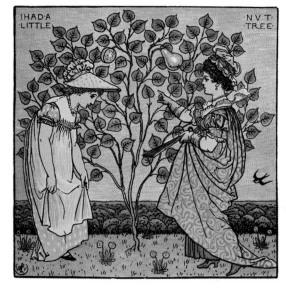

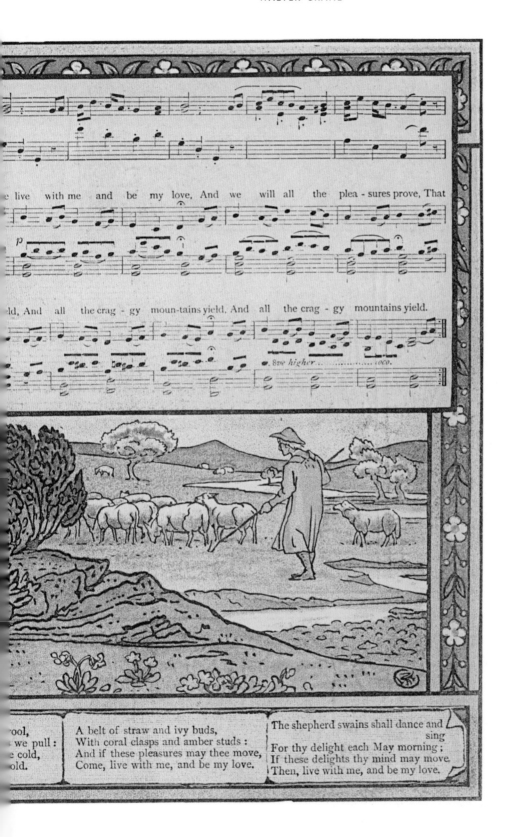

Family and reading

Crane found children's books a delight in the late 1870s because he now had a family of his own. He used his wife, Mary, and their baby daughter Beatrice, born in Rome in February 1873, as models when he illustrated the poem 'My Mother' by Ann Taylor. Then came two boys, Lionel in 1876, and Lancelot in 1880: two other children died young and there is poignancy as well as amusement in his drawings of children.

The Cranes lived first in Florence House in Wood Lane, Shepherd's Bush, moving in 1875 to nearby Beaumont Lodge with its garden studio, taking over the lease from

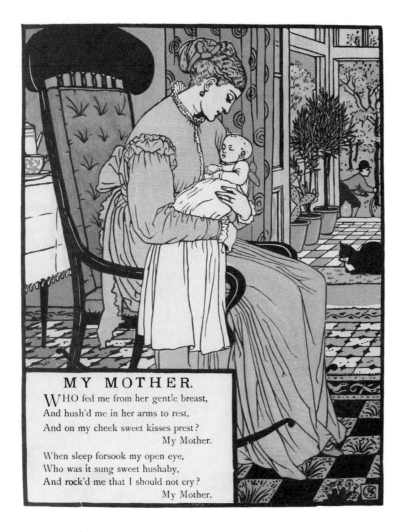

MY MOTHER.

WHO fed me from her gentle breast,
And hush'd me in her arms to rest,
And on my cheek sweet kisses prest?
　　　　　My Mother.

When sleep forsook my open eye,
Who was it sung sweet hushaby,
And rock'd me that I should not cry?
　　　　　My Mother.

LEFT
My Mother, 1873

their friend the painter Edward Poynter. The success of *The Baby's Opera*, *Baby's Bouquêt* and *The First of May* came, Crane was sure, from drawing 'in a congenial atmosphere, and in full view of child life around one, and in the observation of the ways of animals and flowers, and in a studio surrounded by an old garden and orchards and meadows – although not much beyond the four-mile radius of Charing Cross'. It was a noisy, bohemian household, full of paintings and odd objects, where friends gathered for dressing-up parties and pet animals roamed the rooms, including, at one point, an alligator. Crane drew stories for the children in pencil and ink and watercolour wash in notebooks, known as the 'black books', from the predominant colour of their covers.

Like the Toy Books, these mixed real life and fantasy: Beatrice might appear with her doll or learning Italian from a lizard. In 'Beatrice in Fairyland', made for her sixth birthday, she flies on a magic carpet and is rescued from the monster of bad spelling by the friendly alphabet letters. Two years later, Crane drew 'Beatrice: Her Book of Beauties', a pioneering comic strip. He put the boys into adventures full of animals: frogs and guinea pigs and rabbits, horses and dogs, and made writing and painting books for them. Later came the endearing 'Mr Michael Mouse Unfolds his Tale', with illustrations that look forward to Beatrix Potter and modern animal tales. Nearly thirty notebooks exist, but only two stories, *Legends for Lionel* and *Lancelot's Levities*, were published in Crane's lifetime.

Crane's sensitivity to children, shown in the *Baby's Opera* and the family books, let him make teaching fun. In 1884 and 1885 he drew simple, striking designs for a two-part alphabet reader, J. M. D. Meiklejohn's *Golden Primer*. He believed fervently that education should not be rule-bound, but should focus on bringing out the capacities of each individual. In 1886, in an exchange with Ruskin, he argued that the infant mind 'is naturally fearless, open, inquiring, logical' and should never be abused by spurious links between morality and religion, or hidebound ideas. Children learned first of all through their eyes, 'their chief organ for the reception of ideas'. As an artist it was his task to make those ideas clear.

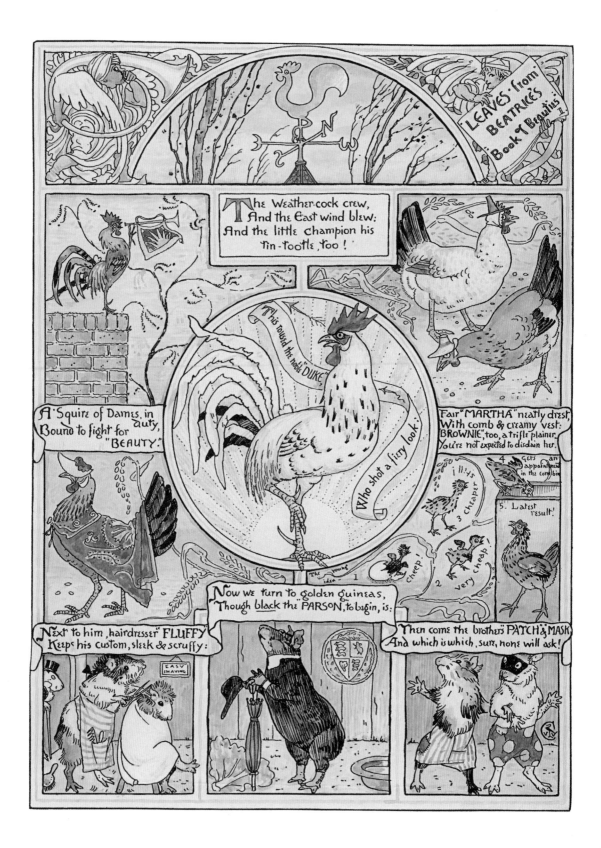

LEAVES from BEATRICE'S Book of Beauties I

The Weather-cock crew,
And the East wind blew:
And the little champion his
tin-tootle, too!

This roused the noble "DUKE"
Who shot a fiery look!

A "Squire of Dames," in duty,
Bound to fight for "BEAUTY".

Fair "MARTHA" neatly drest,
With comb & creamy vest:
"BROWNIE", too, a trifle plainer
You're not expected to disdain her.

The young idea 1

Cheep! 2 very cheep! 3 cheaper I buys

4 Gets an apprentice in the corn-bin

5. Latest result!

Now we turn to golden guineas,
Though black the "PARSON", to begin, is:

Next to him, hairdresser "FLUFFY"
Keeps his custom, sleek & scruffy:

EASY SHAVING

Then come the brothers PATCH & MASK
And which is which, sirs, none will ask!

70

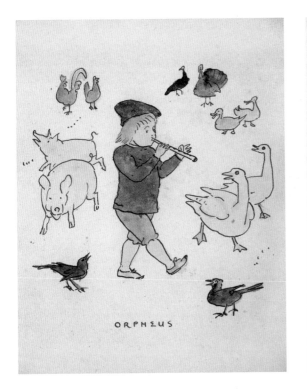

ORPHEUS

Mother in the business
of her work·a·day,
In came little Lancelot,
and crowned her Queen of May!

Next day I
tried the ladder again

OPPOSITE
'Beatrice: Her Book of Beauties',
1881

ABOVE LEFT
'Lionel as Orpheus', c. 1881

ABOVE RIGHT
'Lancelot's Looking Glass', 1888

RIGHT
'Mr Michael Mouse', n.d.

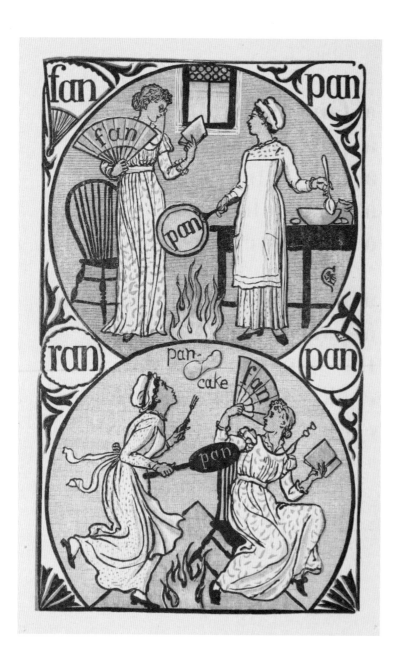

With his brother Tom's firm of Marcus Ward, he published his *Romance of the Three R's* in 1886, binding together three short books (also published separately): *Little Queen Anne*, *Slateandpencil-vania* and *Pothooks & Perseverance*. Like the stories he wrote for his own children, these were drawn in pen and ink with watercolour wash. Queen Anne climbs up on a staircase of 'easy steps of one syllable';

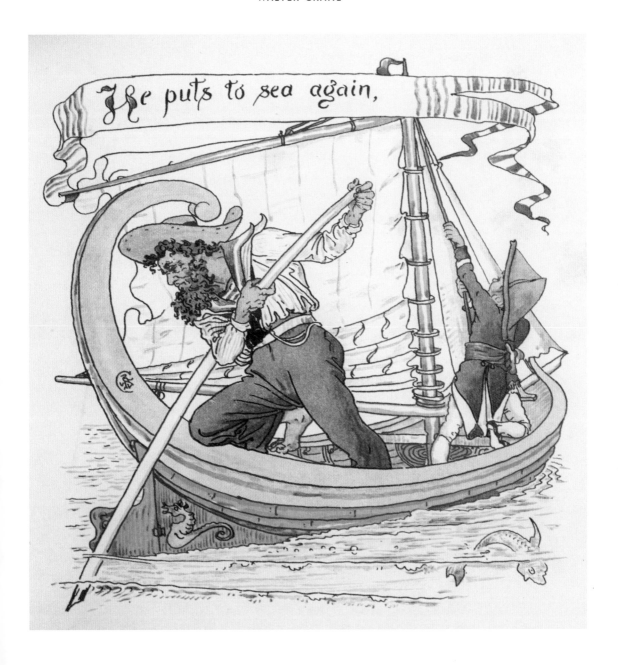

Slateandpencil-vania is a busy desert island story, and *Pothooks & Perseverance* is packed with visual and verbal puns. A sailor ('AB' – able seaman) steering with a pen, takes 'Percy Vere' out to sea in a 'C', and when Percy finally grapples with the ABC serpent, he 'puts it down in black and white with a bold hand'.

Black-and-white Grimm

In the 1870s Crane was also developing a new style in black and white. For C. Kegan Paul, he drew frontispieces for Robert Louis Stevenson's *Inland Voyage* (1878) and *Travels with a Donkey in the Cévennes*. For Macmillan and Co., he illustrated Dinah Mulock's novels and Mrs Molesworth's moral tales, a collaboration continued in eighteen books over many years. Though often overlooked, many of these illustrations are lovely examples of his

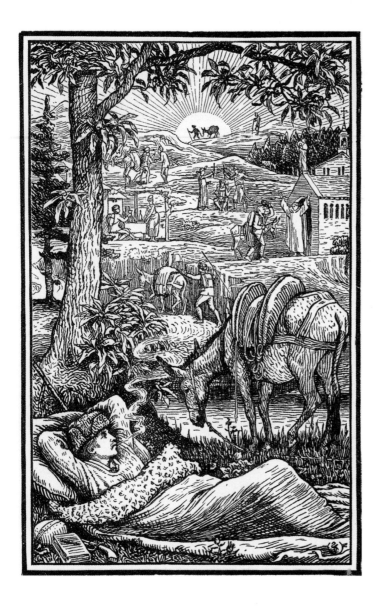

LEFT
Frontispiece, *Travels with a Donkey in the Cévennes*, 1879

74

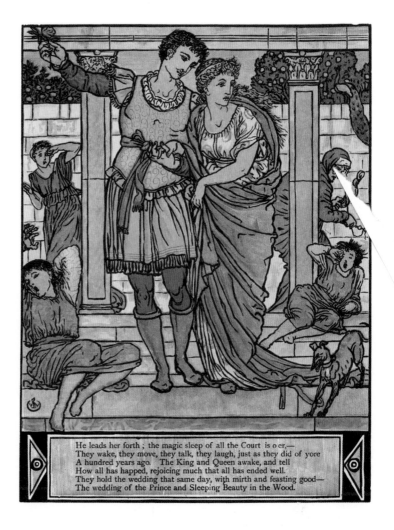

He leads her forth ; the magic sleep of all the Court is o'er,—
They wake, they move, they talk, they laugh, just as they did of yore
A hundred years ago. The King and Queen awake, and tell
How all has happed, rejoicing much that all has ended well.
They hold the wedding that same day, with mirth and feasting good—
The wedding of the Prince and Sleeping Beauty in the Wood.

When Crane lectured on 'The Decorative Illustration of Books' in 1889, he presented Blake as a forerunner:

> *William Blake is distinct, and stands alone. A poet and a seer, as well as a designer, in him seemed to awake something of the spirit of the old illuminator... When he came to embody his own thoughts and dreams, he recurred quite spontaneously to the methods of the maker of the MS books.*

From now on he felt even more urgently that the illustrator's skill, celebrating ideals of freedom and awakening, must work for the socialist dream.

ABOVE
The Sleeping Beauty, 1876

Arts and Crafts Gothic

Crane had admired William Morris's work and writings
since the 1860s. He shared his anti-imperialism and his
despair at the inequities of society and was energized by
his fiery lectures. Many of Morris's admirers were dismayed
when he joined H. M. Hyndman's Democratic Federation
in 1884 (soon the Social Democratic Federation, or SDF)
but Crane was won over after an exchange about Morris's
pamphlet *Art and Socialism*: 'the difficulties disappeared,
and from the verge of pessimism as regards human progress,
I accepted the Socialist position, which became a universal
solvent in my mind'. Crane joined Morris's Socialist League,
a splinter group from the SDF, in 1885, and provided
designs for the cards and for the League's journal, *The
Commonweal*. Five years later, he assisted Morris in
forming the Hammersmith Socialist Society.

In 1886, Morris asked Crane to draw a cartoon for Morris
& Co. for a tapestry based on 'Goose Girl' in *Household Tales*.
Although Crane's scheme did not really work on such a huge
scale, the project reinforced their joint mission to elevate
the crafts. Crane was now firmly caught up in the Arts
and Crafts movement. In 1882, he had joined 'The Fifteen',
a group of painters, designers, architects and one sculptor,
who held monthly meetings to exchange ideas. Two years
later he was one of the founders of the Art Workers' Guild.
By 1888, when the Arts & Crafts Exhibition Society held
their first exhibition in the New Gallery in Regent Street
(where his wife, Mary, also exhibited her embroideries), he
was a central figure: Master of the Guild in 1888–89 and
President of the Exhibition Society from the late 1880s
until 1912, apart from 1893–96 when Morris took over.

Crane and Morris also worked together on the large
quarto edition of Morris's socialist fantasy *The Story of the
Glittering Plain*. While Morris designed the initials and
borders, Crane provided the pictures, engraved by Mary's
cousins Arthur and Ernest Leverett. He tried hard to suit
Morris's tastes, although he feared that his work was not
'quite Gothic enough in feeling', and it's true that his pure
lines are sometimes lost in the heavy engraving or swamped
by the decoration. But the effect was eye-catching, and

OPPOSITE, ABOVE LEFT
Hammersmith Socialist Society
membership card

OPPOSITE, ABOVE RIGHT
Arts & Crafts Exhibition Society
card, 1888

OPPOSITE, BELOW
The Story of the Glittering Plain,
1894

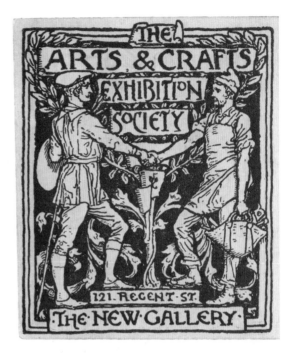

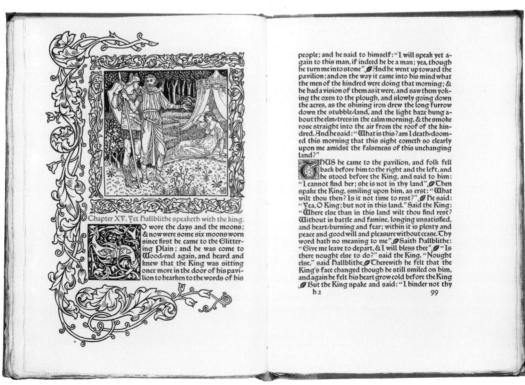

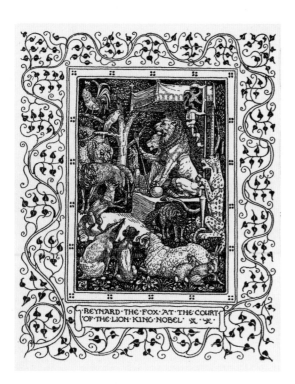

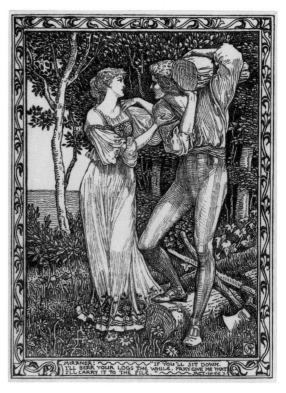

in the same year he illustrated another 'Gothic' work for Morris's friend F. S. Ellis of the Chiswick Press, an edition of Caxton's *History of Reynard the Fox*, drawing his own Morris-like borders of curling vines.

He used a lighter version of this elaborate style in 1893–94 for illustrations of Shakespeare's *Tempest*, *The Merry Wives of Windsor* and *Two Gentlemen of Verona*. And he was less consciously archaic in his grandest project in this vein, illustrating Edmund Spenser's *Faerie Queene*, again for the Chiswick Press. This appeared in nineteen parts between 1894–97, with a head- and tailpiece and full-page illustrations for all twelve cantos – in all Crane

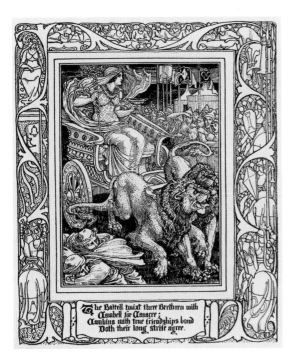

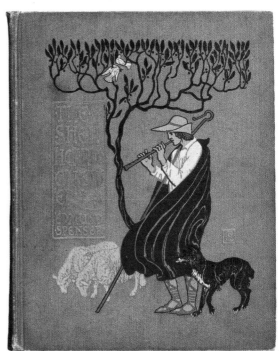

drew 231 illustrations. The woodcuts were still heavy, but the images were lively and imaginative, full of his passion for the poem as an allegory of the quest for an ideal society.

With startling ease, Crane then recaptured his old flair in the elegant, clear lines of the little *Shepheard's Calender*, Spenser's first major work. The bold, simple cover shows a solitary figure in a swirling cape with his dog and his sheep. A breeze seems to blow through the whole book. In the off-centre placing of the pictures, the movement of the figures and the timeless pastoral setting, Crane the illustrator begins to breathe again.

Socialism and art

'Let our aims be the abolition of class and the establishment of a truly human democracy,' urged Crane, lecturing on 'Art and Social Democracy'. He began to talk on art and socialism after meeting George Bernard Shaw at Kelmscott and joining the Fabian Society. The revival of decorative art, he insisted, came not only from its seeking art's 'vital root in the handicrafts but also in its connection with common life and social conditions'. In a society ruled by commerce, where mass production and the monopoly of land and industry brought slavery, poverty and alienation, political liberty could only be achieved by economic freedom, the 'collective and common ownership of the means of subsistence'.

Crane created a style for the international socialist movement. His 1885 oil painting *Freedom* showed a great winged angel freeing a chained youth, the emblem of humanity – wearing the *bonnet rouge* of liberty – from an armed king and hooded priest, and he then used this as an illustrative frame in *The Sirens Three*.

In the mid-1880s Crane the illustrator sprang into action. In the year that he painted *Freedom*, 1885, he drew a vehement cartoon, *The Capitalist Vampire*, for Hyndman's journal *Justice*. Brooding over the evils of imperialism, he produced an extraordinary map of the British Empire, asking for Freedom, Fraternity and Federation across the world. When his old master, Linton, sent a set of verses

BELOW
Political postcards and greetings cards

OPPOSITE
The Sirens Three, 1886, plate LXXIII

 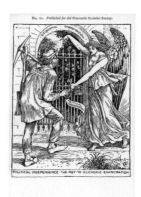

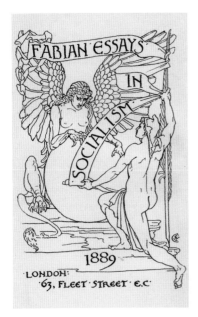

see,' Crane told Shaw, 'the sphinx of individualism is clutching the world while the AEdipus of Socialism arrives with the true answer to the riddle – political, moral, economic, social, and she is checkmated.'

He held to these ideals, wearing the cap of liberty in a studio photograph with Lionel. Crane was horrified at the police violence during socialist rallies in November 1887, designing a memorial pamphlet to raise money for the daughter of Alfred Linnell, killed by the charging mounted police. As a Fabian he believed in gradual change through education rather than violent revolution, and in the 1890s, influenced by the anarchist-communist ideas of Kropotkin – whom he met and admired – his interest grew in communal, voluntary associations, where the artist would work, yet be free to express himself. 'We want a vernacular in art,' Crane wrote, a 'comprehensive and harmonizing unity with

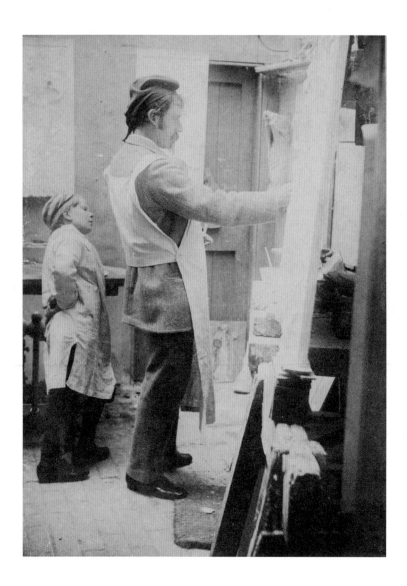

individual variety which can only be developed among
a people politically and socially free.'

Over the years he worked for many different groups,
drawing titles for journals and books, creating processional
banners, socialist postcards and greeting cards. His
designs appeared everywhere. Examples range widely: a
prospectus for Louise Michel's International School, a cover
for Ebenezer Howard's *Garden Cities of To-morrow* (1902),
a menu for Smallman's, a vegetarian baker in Manchester,
illustrations for *The Child's Socialist Reader* (1907) and
designs for the cycling club of Robert Blatchford's *Clarion*

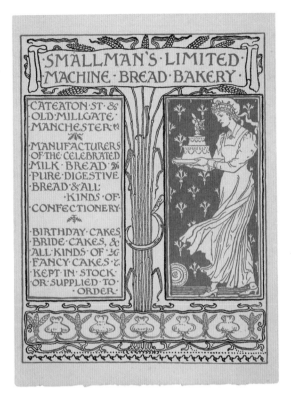

newspaper, for the British Esperantists, for women's suffrage demonstrations, and for the Healthy and Artistic Dress Union. (Mary was equally keen on this drive against tight-lacing, though sweetly admitting at a meeting in 1906 that 'she now liked a little support herself'.) Even dress could be a gesture towards liberty.

Advertisements for life insurance companies reflected Crane's practical concerns for workers' welfare. And he was connected with lasting institutions: he proposed a mosaic for the front of the Whitechapel Art Gallery, designed to bring art to the poor; with Georgie Burne-Jones and others he set up the workshop and library that became Camberwell School of Art; with Morris and the architect Larner Sugden he designed stencils for the brilliantly coloured walls of the 'William Morris Labour Church' in Leek, Staffordshire.

At the time, tableaux and masques, looking back to the 17th century, were much in vogue. (Crane was on the committee of the Stage Society and later a key figure in the Masquers Society, with Gordon Craig and W. B. Yeats, whom

ABOVE
Advertisement for Smallman's
Bakery and Restaurant

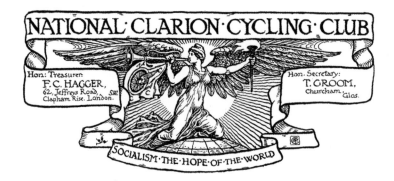

he liked greatly with his pale face, long black hair, 'quiet manner and dreamy look'.) In 1899, he organized a masque for the Art Workers' Guild, called *Beauty's Awakening*, with music by Arnold Dolmetsch, suggesting how art under socialism could be free from capital and patronage, as in the ideal cities of Princess Fayremond's dream:

> *In all man's labour, as with craft and art*
> *Each thing of use had life to cheer the heart,*
> *And pictured walls emblazoned with mighty deeds*
> *With all the people's lore, for daily needs.*

In the *Saturday Review*, Max Beerbohm was pleased that the contrivers 'aimed not at a mere antiquarian revival, but at an adaptation of an old form to modern notions'.

Crane's major 'modern' socialist work, however, was in creating cartoons to celebrate key days. His elaborate *Triumph of Labour* of 1891, a strange Renaissance-style procession of working men, girls and babies, ox-carts and angels, marked the first International May Day and was printed in French, German and Italian as well as English. Many cartoons, like the intricate 'Garlands' for May Day, contributed annually to Hyndman's magazine *Justice* from 1894 to 1912, kept the decorative framework of his book illustrations, and often seem to look back to rural prosperity, rather than industrial poverty. A selection of his cartoons, *Cartoons for the Cause*, was published as a souvenir for the International Socialist Workers and Trade Union Congress of 1896.

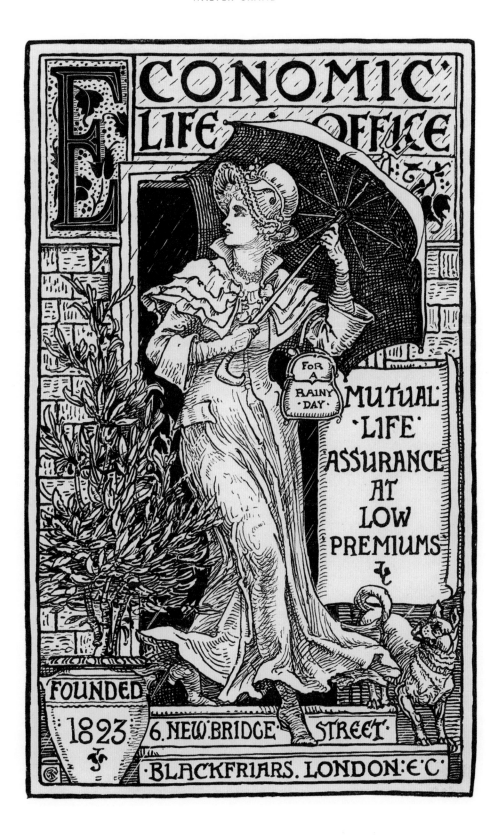

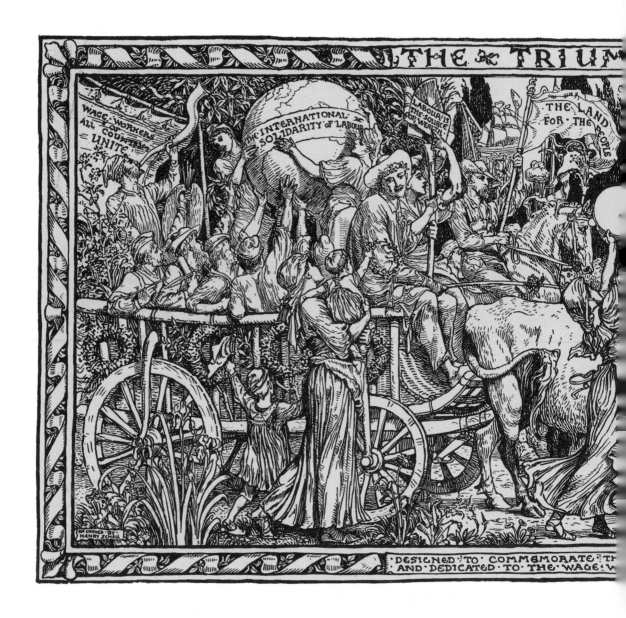

'Nobody, not even William Morris, did more than he to make Art a direct helpmeet to the Socialist propaganda', wrote Hyndman. 'Nobody has had a greater influence on the minds of doubters who feared that Socialism must be remote from and even destructive of the sense of beauty.'

ABOVE

The Triumph of Labour, 1891

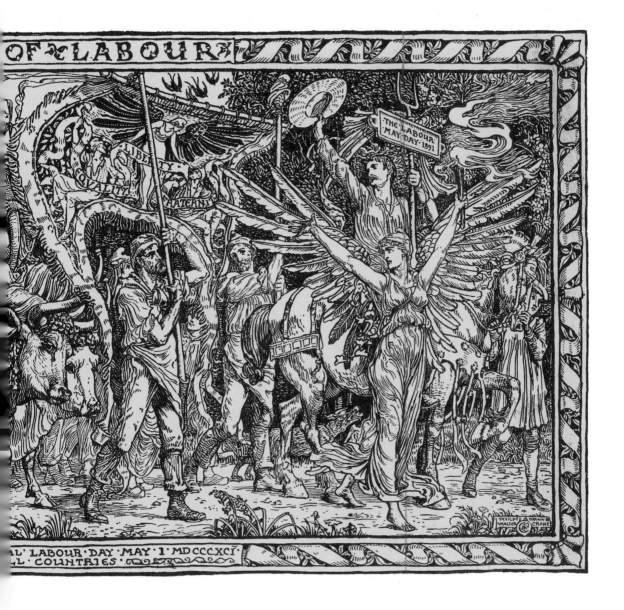

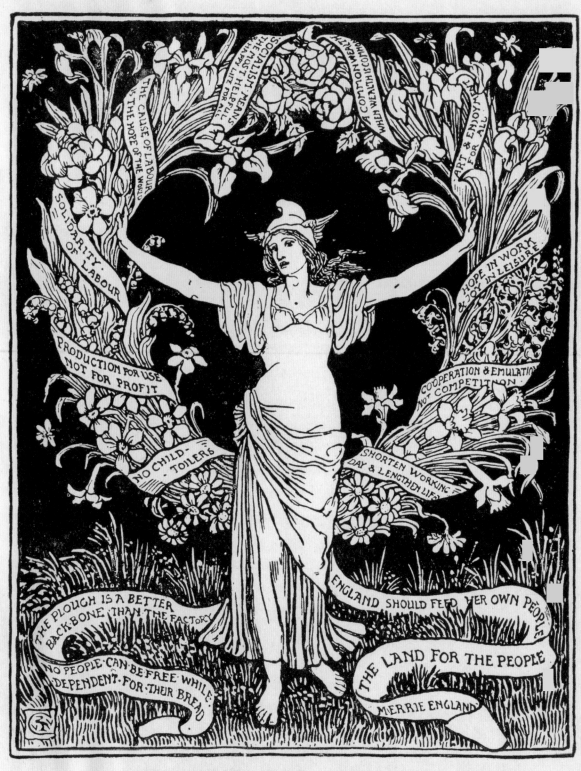

· A · GARLAND · FOR · MAY · DAY · 1895 ·
· DEDICATED · TO · THE · WORKERS · BY · WALTER · CRANE ·

Wonder

Amid his labours for socialism and the Art Workers' Guild, Crane still found time for lighter work. Although he became impatient with the luxury associated with the Aesthetic movement, in 1888 he illustrated Oscar Wilde's stories in *The Happy Prince*, in gentle, tender images. A new wave of artists, including Aubrey Beardsley, acknowledged his influence, while his reputation as a designer soared when the Art Nouveau style took hold in the late 1880s and early 1890s. A retrospective exhibition at the Fine Art Society, Bond Street, in 1891 included 100 items: illustrations, ceramics, textiles, wallpaper, watercolours and oils.

This prompted a touring exhibition in Europe, and then in 1892 – partly to escape England after the death of their toddler Myfanwy, their 'Baby Bunting' – Crane took his family to

OPPOSITE
A Garland for May Day, 1895

RIGHT
The Happy Prince, Plate 2, 1888

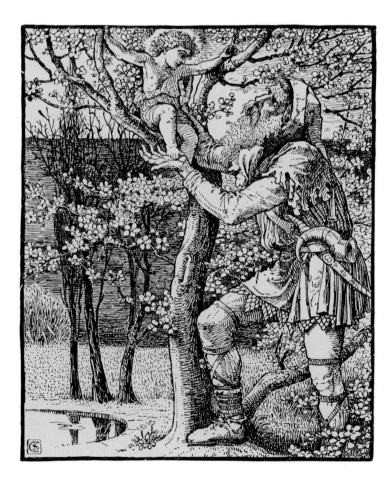

America. Here his defence of the convicted Chicago Anarchists, four of whom had been executed in 1887, offended society leaders but won support from the liberal press. On their tour, the Cranes met literary lions, including Emerson, and visited cities from San Francisco to New York. Invited to produce a commemorative book for the Chicago World's Fair, he wrote an epic poem with twelve illustrations, *Columbia's Courtship* (1893), celebrating the history of the United States while firmly asserting the rights of workers and African-Americans.

In Florida, where Lionel was now living, Crane drew sixty colour drawings and nineteen full-page plates for Nathaniel Hawthorne's *Wonder Book for Girls and Boys*. These were printed as lithographs in six colours, and although at first the grainy effect bothered him, the plates were soft and magical. Here, too, he linked myth to his socialist beliefs, showing Pandora – a favourite emblematic figure – hesitating between Epimetheus in his cap of liberty, and the mysterious box.

BELOW LEFT
The Anarchists of Chicago, in *Liberty: A Journal of Anarchist Communism*, November 1894

BELOW RIGHT
Columbia's Courtship, 1893

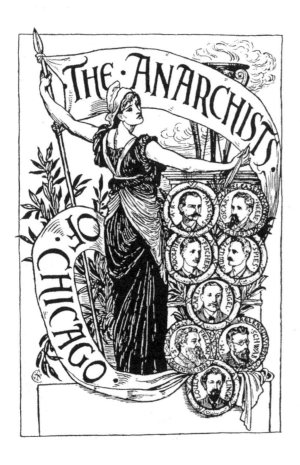

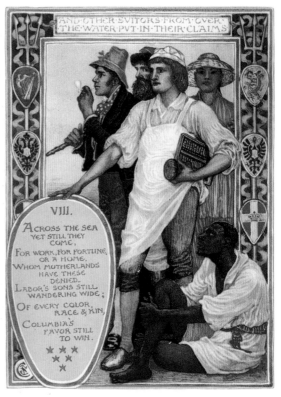

Opened, the box floods the world with evil, yet hope remains, both in the box and in the revolutionary figure.

In the 1890s much of Crane's energy went into organizing and educating. He became Director of Design at Manchester School of Art from 1893 to 1896, and in 1898 he became Principal of the Royal College of Art, but resigned after a year because he had no time for his own work. But for all his energy, Crane was not the best of organizers and colleagues at the Arts and Crafts Exhibition Society chafed at the lack of funds and of leadership to younger members. Crane was, they thought, too much of a dreamer.

In *Line and Form*, written for his Manchester students, he evoked his utopian dream of art and society: the elements of design should, he wrote, 'meet in friendly co-operation; it is not a blind struggle for existence, a fierce competition'.

His friends loved the humour, warmth and eccentricity so evident in his books. On their return from America the

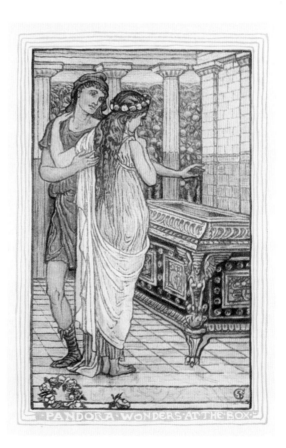

RIGHT
A Wonder Book for Girls and Boys,
1892

Cranes moved to 13 Holland Street, Kensington, filling the house with a dusty clutter – old china, carved figures, Indian idols and model ships, and pets including a marmoset that slept in the fireplace. Mary Crane, according to the architect C. R. Ashbee, was by now a 'kind, motherly, plump, fantastic creature', who drove a pair of ponies in a colourful barouche, and rode in the park in a red velvet gown. They gave many fancy-dress parties and Ashbee had fond memories of Lionel's twenty-first birthday in May 1897, when Mary received seven hundred guests dressed as a sunflower (Crane, of course, came as a crane). 'It is those generous unselfconscious souls,' Ashbee said, 'such as Crane and his wife, that make the world go easy.'

From 1895 to 1914 Crane's Toy Books were re-issued in a larger format by the publisher John Lane, for a new generation. Crane's own children were now grown up and independent: Beatrice an embroiderer and writer, Lionel training as an architect and Lancelot proving a talented artist. But the work Crane had done for them when they were small still bore fruit. The easy confidence of the family books enlivened the flower books of his later years. In *Flora's Feast: A Masque of Flowers* (1889), pattern and freedom, fantasy and observation, Art Nouveau and nature, blend together. This was the first in a series of books, all slightly different in style, as if the tightly controlled floral designs of his wallpaper were allowed to leap into life on the page. *Queen Summer, or, The Tourney of the Lily and the Rose* (1891), had forty medieval-style designs, while Margaret Deland's *Old Garden and Other Verses* (1893), commissioned in America, had free-floating images and ornament, with a contrasting Gothic script.

After the last of these, Arthur Kelly's quirky *Rosebud, and Other Tales* (1909), where Crane's flower fairy mixed with fantastical 'Soap Bubbles', magic mirrors and a conceited tennis ball, all his books were reproduced by colour half-tone printing, with blocks made photographically. This mechanical process allowed Crane to work more directly, without worrying about how the engraver or lithographer would affect the image, and his illustrations were full of evocative details, if more conventional than earlier work. His delight in medieval dress and settings and his feeling

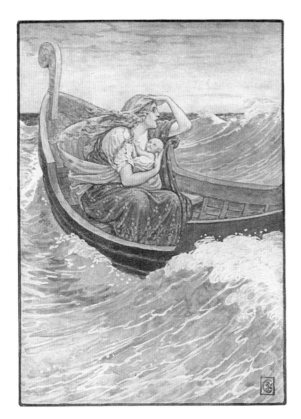

In 1900, a big retrospective exhibition of Crane's work
opened in Budapest. After touring Austria and Germany
in 1902 it was moved to Turin as the English display in
the International Exhibition of Modern Decorative Art (the
Scottish section showed Charles Rennie Mackintosh and
the Glasgow School). In Italy, King Victor Emmanuel III
granted Crane a title, and he called himself 'Commendatore'
with endearing pride, while Mary styled herself 'Mistress
Crane'. Crane himself travelled widely, hearing Wagner at
Bayreuth, and becoming fascinated by peasant dress and
embroidery across Europe. He published his lectures and in
1907 his *Reminiscences*, and *India Impressions*, an account
of a trip with Mary, strongly critical of British rule. He still
campaigned fiercely. A confirmed pacifist, believing wars
were begun by capitalists for gain, he had resigned from the
Fabians in 1900 when they refused to oppose the Boer War,
and he argued passionately for peace up to the First World
War – in which his own son Lancelot would be killed.

Life in Holland Street was full but also troubled. In 1911, Beatrice was involved in a stormy, acrimonious divorce and soon Mary became increasingly ill. After going on a rest cure in Kingsnorth, Kent, on 18 December 1914 she threw herself under a train on the railway line nearby. Distraught, Crane collapsed. He died three months later, on 14 March 1915.

Walter Crane was a leading spirit of the Aesthetic and Arts and Crafts movements and a powerful socialist artist, but to many he was simply the supreme illustrator of fantastical tales. He had always loved masques and fancy-dress balls and dressing up, and as an illustrator and a socialist he was a showman too, opening the curtain on to the stage of fantastical worlds. His magical Toy Books were constantly reprinted, and his vision of Beauty, flowering in harsh conditions, with a strength to awaken and change the world, has a lasting power.

ABOVE AND OPPOSITE

Puss in Boots, endpapers, *Walter Crane's Picture Books*, Vol. 3, 1897

The following is a list of key publications in Crane's lifetime; it does not include the bulk of individual illustrations for books, book covers or magazines.

Principal illustrated books
Toy Books are marked TB

1862
John R. de Capel Wise, *The New Forest: Its History and its Scenery*, Smith, Elder
1865
The Affecting Story of Jenny Wren (TB), Ward, Lock & Tyler
The Comical Cat (TB), Ward, Lock & Tyler
The Farm Yard Alphabet (TB), Routledge
The House that Jack Built (TB), Ward, Lock & Tyler
The Railroad Alphabet (TB), Routledge
Nathaniel Hawthorne, *Transformation: or, The Romance of Monte Beni*, Smith, Elder
1866
Cock Robin (TB), Frederick Warne
A Gaping-Wide-Mouth-Waddling Frog (TB), Frederick Warne
The House that Jack Built (TB), Frederick Warne
Sing a Song of Sixpence (TB), Frederick Warne
1867
Chattering Jack (TB), Routledge
The Multiplication Table in Verse (TB), Routledge
The Old Courtier (TB), Routledge
John Aikin & Mrs Barbauld, *Evenings at Home*, Frederick Warne
1868
Grammar in Rhyme (TB), Routledge
How Jessie was Lost (TB), Routledge
1869
Annie and Jack in London (TB), Routledge
One, Two, Buckle My Shoe (TB), Routledge
1870
The Absurd ABC (TB), Routledge
The Adventures of Puffy (TB), Routledge
The Fairy Ship (TB), Routledge
King Luckieboy's Party (TB), Routledge
1871
King Luckieboy's Picture Book (TB), Routledge
This Little Pig went to Market (TB), Routledge
1872
Noah's Ark Alphabet (TB), Routledge
1873
Ali Baba and the Forty Thieves (TB), Routledge

Cinderella (TB), Routledge
My Mother (TB), Routledge
The Three Bears (TB), Routledge
Walter Crane's New Toy Book (TB), Routledge
1874
The Absurd ABC (TB), Routledge
An Alphabet of Old Friends (TB), Routledge
Beauty and the Beast (TB), Routledge
The Frog Prince (TB), Routledge
Goody Two Shoes (TB), Routledge
Old Mother Hubbard (TB), Routledge
Puss in Boots (TB), Routledge
Valentine and Orson (TB), Routledge
Walter Crane's Picture Book (TB), Routledge
1875
Aladdin, or, The Wonderful Lamp (TB), Routledge
Baby's Own Alphabet (TB), Routledge
Bluebeard (TB), Routledge
The Hind in the Wood (TB), Routledge
Jack and the Beanstalk (TB), Routledge
Little Red Riding Hood (TB), Routledge
Mrs Mundi at Home: The Terrestrial Ball, R.S.V.P., Marcus Ward
Princess Belle-Etoile (TB), Routledge
The Yellow Dwarf (TB), Routledge
Mary Molesworth, *Tell Me a Story* (1st of 18 books, all Macmillan)
1876
Absurd Alphabet, Baby's Own Alphabet & Noah's Ark Alphabet (combined edition; TB), Routledge
Chattering Jack's Picture Book (TB), Routledge
The Quiver of Love: A Collection of Valentines, with Kate Greenaway, Marcus Ward
The Sleeping Beauty in the Wood (TB), Routledge
1877
The Baby's Opera: A Book of Old Rhymes with New Dresses, Frederick Warne
Mother Goose's Nursery Rhymes, with other illustrators, Routledge
1878
The Baby's Bouquêt, Routledge
1879
The Children's Musical Cinderella (TB), Routledge
1880
Mary de Morgan, *The Necklace of Princess Fiorimonde*, Macmillan
1881
John R. de Capel Wise, *The First of May: A Fairy Masque*, Henry Sotheran
1882
Household Stories from the Collection of the Brothers Grimm, trans. Lucy Crane, Macmillan

1883
Theo Marzials, *Pan-Pipes: A Book of Old Songs*, Routledge
1884–85
J. M. D. Meiklejohn, *The Golden Primer*, Parts 1 & 2, Blackwood
1885
Slateandpencil-vania, Marcus Ward
Mrs Burton Harrison, *Folk and Fairy Tales*, Ward and Downey
1886
Little Queen Anne, Marcus Ward
Pothooks & Perseverance: or the ABC-Serpent, Marcus Ward
A Romance of the Three R's, Marcus Ward
The Sirens Three: A Poem, Macmillan
1887
Legends for Lionel, in Pen and Pencil, Cassell
Little Miss Peggy: Only a Nursery Story, Macmillan
The Baby's Own Aesop: Being the Fables Condensed in Rhyme, Routledge
George C. Warr, *Echoes of Hellas*, 2 vols, Marcus Ward
1888
Oscar Wilde, *The Happy Prince and Other Tales*, David Nutt
1889
The Book of Wedding Days, Longmans
Flora's Feast: A Masque of Flowers, Cassell
Beatrice Crane, *The Procession of the Months*, R. H. Bath, Wisbeach (reissued in Little Folks annual 1891, and in 1907)
1891
Queen Summer, or, The Tourney of the Lily and the Rose, Cassell
Renascence: A Book of Verse, Elkin Mathews
1892
Nathaniel Hawthorne, *A Wonder Book for Girls and Boys*, Osgood, McIlvaine
1893
Columbia's Courtship, Louis Prang, Boston
Margaret Deland, *The Old Garden and Other Verses*, Osgood, McIlvaine
William Shakespeare, *The Tempest*, J. M. Dent
1894
The History of Reynard the Fox, trans. F. S. Ellis, David Nutt
Elizabeth Harrison, *The Vision of Dante*, Chicago Kindergarten College
William Morris, *The Story of the Glittering Plain*, Kelmscott Press
William Shakespeare, *The Merry Wives of Windsor*, George Allen
William Shakespeare, *Two Gentlemen of Verona*, J. M. Dent

Edmund Spenser, *The Faerie Queene*, ed. T. J. Wise (19 parts, 1894–97), George Allen

1895
Walter Crane's Picture Books, Vol. 1: *This Little Pig his Picture Book* (TB reissue), John Lane
H. C. Beeching, *A Book of Christmas Verse*, Methuen

1896
Cartoons for the Cause 1886–1896: A Souvenir of the International Socialist Workers and Trade Union Congress, 1896, Twentieth Century Press

1897
'The Craftsman's Dream', *Labour Leader*, 1 May
Walter Crane's Picture Books, Vol. 2: *Mother Hubbard her Picture Book* (TB reissue), John Lane
—, Vol. 3: *Cinderella's Picture Book* (TB reissue), John Lane

1898
A Floral Fantasy in an Old English Garden, Harper & Brothers
Walter Crane's Picture Books, Vol. 4: *Red Riding Hood's Picture Book* (TB reissue), John Lane
Edmund Spenser, *The Shepheard's Calender*, Harper & Brothers

1899
Beauty's Awakening: A Masque of Winter and Spring, The Studio, special summer number
Walter Crane's Picture Books, Vol. 5: *Bluebeard's Picture Book* (TB reissue), John Lane
Nellie Dale, *The Dale Readers*, George Philip & Son

1900
Don Quixote of the Mancha, re-told by Judge Parry, Blackie
Walter Crane's Picture Book, Frederick Warne

1901
Walter Crane's Picture Books, Large Series, Vol. 1: *Beauty and the Beast Picture Book* (TB reissue), John Lane
—, Vol. 2: *Goody Two Shoes Picture Book* (TB reissue), John Lane
Charles Lamb, *A Masque of Days: from the Last Essays of Elia*, Cassell

1905
A Flower Wedding, Cassell

1906
Flowers from Shakespeare's Garden: A Posy from the Plays, Cassell

1907
A. A. Watts, *The Child's Socialist Reader*, Twentieth Century Press

1909
Walter Crane's Picture Books, Large Series, Vol. 3: *The Song of Sixpence*

Picture Book (TB reissue), John Lane
Arthur Kelly, *The Rosebud, and Other Tales*, T. Fisher Unwin

1910
Walter Crane's Picture Books, Large Series, Vol. 4: *The Buckle My Shoe Picture Book* (TB reissue), John Lane
F. J. Gould, *The Children's Plutarch*, Harper & Brothers

1911
Alfred C. Calmour, *Rumbo Rhymes, or, The Great Combine, a Satire*, Harper & Brothers
Henry Gilbert, *King Arthur's Knights*, T. C. & E. C. Jack

1912
Henry Gilbert, *Robin Hood and the Men of the Greenwood*, T. C. & E. C. Jack
Mary Macgregor, *The Story of Rome*, T. C. & E. C. Jack

1913
Mary Macgregor, *The Story of Greece*, T. C. & E. C. Jack

1914
Puss in Boots and The Forty Thieves (TB reissue), John Lane
The Sleeping Beauty and Bluebeard (TB reissue), John Lane
The Three Bears and Mother Hubbard (TB reissue), John Lane

Lectures and other works
In chronological order

Lucy Crane, *Art and the Formation of Taste*, Macmillan, 1882
Arts & Crafts Exhibition Society: *Catalogue of the First Exhibition, New Gallery, 1888*, The Society, 1888
The Claims of Decorative Art, Lawrence and Bullen, 1892
On the Study and Practice of Art: An Address, Saturday, March 4th, 1893, Manchester Guardian Printing Works, 1893
Of the Decorative Illustration of Books Old and New, George Bell & Sons, 1896
The Bases of Design, George Bell & Sons, 1898
'The Work of Walter Crane, with Notes by the Artist', *Easter Art Annual, 1898*, Art Journal, J. S. Virtue, 1898
Great Masters of Decorative Art: Sir Edward Burne-Jones, by Aymer Vallance; William Morris, by Lewis F. Day; Walter Crane with notes by himself, Art Journal, 1900
Line and Form, George Bell & Sons, 1900
Moot Points: Friendly Disputes on Art & Industry between Walter Crane and Lewis F. Day, B. T. Batsford, 1903

Ideals in Art: Papers Theoretical, Practical, Critical, George Bell & Sons, 1905
India Impressions: with some notes of Ceylon during a Winter Tour, 1906–7, Methuen, 1907
An Artist's Reminiscences, Methuen, 1907
Hazelford Sketch Book, The John Barnard Associates, Cambridge, MA, 1937
Mr Michael Mouse Unfolds His Tale, Yale University Library, New Haven, CT, 1956

Select secondary works
Paul George Konody, *The Art of Walter Crane*, George Bell & Sons, 1902
Catalogue of Memorial Exhibition of Paintings and Water-Colour Drawings by Walter Crane, Bromhead, Cutts & Co., 1920
Gertrude C. E. Massé, *A Bibliography of First Editions of Books Illustrated by Walter Crane*, The Chelsea Publishing Co., 1923
Rodney K. Engen, *Walter Crane as a Book Illustrator*, Academy Editions, 1975
Isobel Spencer, *Walter Crane*, Studio Vista, 1975
Greg Smith and Sarah Hyde (eds), *Walter Crane 1845–1915: Artist, Designer and Socialist*, Lund Humphries in association with the Whitworth Art Gallery, University of Manchester, 1989
David E. Gerard, *Walter Crane and the Rhetoric of Art*, Nine Elms Press, 1999
Anne H. Lundin, *Victorian Horizons: The Reception of the Picture Books of Walter Crane, Randolph Caldecott and Kate Greenaway*, Scarecrow Press, 2001
Tomoko Masaki, *A History of Victorian Popular Picture Books*, Kazamashobo, Tokyo, 2006
Morna O'Neill, 'Art and Labour's Cause is One': Walter Crane and Manchester 1880–1915, Whitworth Art Gallery, Manchester, 2008
Helen Stalker, *From Toy Books to Bloody Sunday: Tales from the Walter Crane Archive*, Whitworth Art Gallery, Manchester, 2009
Morna O'Neill, *Walter Crane: The Arts and Crafts, Painting, and Politics, 1875–1890*, Yale University Press, 2010
Harvard Library Bulletin, 26:1–2 (Spring–Summer 2015), Special Walter Crane Issue, Hope Mayo and Francesca Tancini

1845 15 August, Walter Crane born in Liverpool. In November, family moves to Upton, near Torquay

1857 May, the Cranes move to London, 2 Alfred Villas, Shepherd's Bush

1858 Cranes move to Lambton Terrace, Notting Hill

1859 January, begins apprenticeship with W. J. Linton, 33 Essex Street. July, his father, Thomas Crane, dies

1861–63 Illustrations for *Illustrated London News*, *London Society*, *Once a Week*, *Good Words*

1862 January, apprenticeship ends. Painting: *The Lady of Shalott* hung at Royal Academy of Arts. Illustrations for *The New Forest*

1863 Begins work with Edmund Evans: illustrations, e.g. for F. G. Trafford, *The Moors and the Fens*. First visit to Peak District, Derbyshire, with John R. Wise

1865 Illustrations for N. Hawthorne, *Transformation*; Thomas Day, *The History of Sandford and Merton*. First Toy Books for Evans

1866 February, visits Paris with his brother Tom. July, illustration in *Punch*. Sixpenny Toy Books begin

1869 Black-and-white work includes C. Marshall, *King Gab's Story Bag*

1871 6 September, Crane marries Mary Frances Andrews at All Souls, Langham Place. They travel to Italy, living in Rome until 1873

1873 February, Beatrice Crane born. May, the Cranes return to London, settling in Shepherd's Bush. Routledge launch sixpenny 'New Series of Walter Crane's Toy Books'

1874 Launch of 'Shilling Series'

1875 Begins work for Macmillan & Co. on black-and-white illustration

1876 Moves to Warne & Co. after end of contract with Routledge. Lionel Crane born

1877 Exhibits *The Renaissance of Venus* in newly opened Grosvenor Gallery, with Burne-Jones and Whistler

1878 Painting: *The Fate of Persephone*

1880 Lancelot Crane born. Becomes Art Superintendent of the London Decorating Company

1880–81 Exhibition of decorative design at Grosvenor Gallery

1881 Eustace Crane born. December–January, visits Italy

1882 January, Eustace dies. 31 March, Lucy Crane dies. Publication of Lucy Crane, *Art and the Formation of Taste*. Joins 'The Fifteen' group

1884 Arts Workers' Guild founded. Exhibits at Institute of Painters in Water Colours in Piccadilly (resigns 1886). Follows William Morris in joining the Democratic Federation. December, first socialist cartoon, *The Party Fight and the New Party*

1885 March, joins Morris's Socialist League. April–September, *The Sirens Three* in the *English Illustrated Magazine*. July, cartoon: *The Capitalist Vampire*. October, becomes a member of the Fabian Society, lectures on 'Art and Commercialism'.

1886 Work in English section of the Berlin International Exhibition

1887 20 November, fatal injury of friend Alfred Linnell in socialist rally

1888 Myfanwy Crane born. April–mid-May, visits Greece. First Arts & Crafts Exhibition, New Gallery, Regent Street. Master of Art Workers' Guild 1888–89; President of Exhibition Society until 1912 (apart from 1893–96 when Morris takes over). Associate member of the Old Water-Colour Society: exhibits with them for rest of life. Illustrations for Oscar Wilde, *The Happy Prince*

1889 Wins silver medal at Paris Universal Exhibition. *Flora's Feast* – first of series of flower books

1890 Joins Morris in forming the Hammersmith Socialist Society. Vice President of the Healthy and Artistic Dress Union

1891 18 March, death of Myfanwy Crane, 'Baby Bunting'. First retrospective show, Fine Art Society, Bond Street. Publication of *Renascence: A Book of Verse*. August, G. F. Watts paints Crane's portrait. Included in the exhibition of 'Les XX' in Brussels

1892 Visit to America. Talks and Socialist lectures published in *The Claims of Decorative Art*. December, moves to 13 Holland Street, Kensington

1893 Part-time Director of Design at Manchester School of Art (to 1896). Crane exhibition at Museum of Decorative Art, Berlin; it then tours Europe through to 1896

1894 Crane and Mary visit Bayreuth. Illustrations to Morris, *The Story of the Glittering Plain*, for Kelmscott Press, and Caxton's *The History of Reynard the Fox*, printed by the Chiswick Press

1894–97 Illustrations to Spenser, *Faerie Queene*, ed. T. J. Wise, 19 parts

1896 3 October, Morris dies. Work shown in Copenhagen, Stockholm and Christiana Museum of Applied Art

1898 Spenser, *Shepheard's Calender*, printed by the Chiswick Press. July, becomes Principal of Royal College of Art; resigns after a year

1899 29 June, *Beauty's Awakening: A Masque of Winter and Spring* put on at Guildhall of the City of London. Crane plays Dürer

1900 Resigns from Fabian Society in protest against their attitude to the Boer War. *Don Quixote of the Mancha*, re-told by Judge Parry. Publication of *Line and Form*. Touring exhibition at Museum of Applied Arts, Budapest; triumphal visit to Hungary

1901 Second exhibition in Vienna. Summer, visit to Ireland

1902 Turin Exhibition. Paul G. Konody, *The Art of Walter Crane*

1903 2 January, full member of Royal Society of Painters in Water Colours. 10 January, awarded 'Croce di Grande Ufficiale dell'ordine della Corona d'Italia'. Takes title Commendatore. March, chairs inaugural meeting of the Masquers Society

1904 Awarded Albert Medal of Royal Society of Arts

1905 *Ideals in Art*, collection of papers, with illustrations by students at the Royal College

1906–07 Winter visit to India and Ceylon (Sri Lanka)

1912 January, awarded rank of Cavaliere by King Victor Emmanuel III of Italy

1914 18 December, Mary Crane found dead on railway line in Kent. Coroner's verdict: suicide during temporary insanity

1915 14 March, Crane dies at Horsham Cottage Hospital, Sussex

Dimensions are given in centimetres (followed by inches)
a = above; b = below; c = centre; l = left; r = right

2 *The Song of Sixpence Picture Book*, London: John Lane, 1909; **4** Collection of Roger Thorp; **6** *The Work of Walter Crane*, London: J. S. Virtue & Co., 1898; **7** Beinecke Library, Yale University, New Haven, CT; **8** Anthony Crane Collection, UK/Bridgeman Images; **10** F. J. Gould, *The Children's Plutarch*, New York & London: Harper & Bros, 1910; **11** The Caroline Miller Parker Collection, The Walter Crane Archive. Houghton Library, Harvard University, Cambridge, MA; **13** Courtesy the Whitworth, The University of Manchester; **14** Private collection; **15** Oil on canvas, 24.1 × 29.2 (9½ × 11½). Yale Center for British Art, New Haven, CT. Paul Mellon Fund (B1986.24); **16** Oil on canvas, 25.5 × 33.5 (10 × 13¼). Private collection, PD/Sotheby's; **17** Alfred Tennyson, *Poems*, London: E. Moxon, 1857; **19a** Oil on canvas, 122.5 × 183.3 (48¼ × 72⅛). Laing Art Gallery, Newcastle upon Tyne, UK. Photo Granger/Shutterstock; **19b** Courtesy the Whitworth, The University of Manchester; **20** Beinecke Library, Yale University, New Haven, CT; **22** John Richard de Capel Wise, *The New Forest*, London: Smith, Elder, 1862; **23l** Photo 2018 Malcolm Warrington/fotoLibra; **23r** George MacDonald, *At the Back of the North Wind*, London: Strahan & Co., 1871; **24** Heraclitus Grey (C. Marshall), *King Gab's Story Bag*, London & New York: Cassell, Petter & Galpin, 1869; **25, 26** *Walter Crane Hazelford Sketch Book*, Cambridge, MA: John Barnard Associates, 1937; **28** Bret Harte, *Sensation Novels*, London: Ward, Lock & Co., 1875; **29** *The Affecting Story of Jenny Wren*, London: Ward, Lock & Tyler, 1865; **30, 31** Courtesy the Whitworth, The University of Manchester; **32, 33** The Caroline Miller Parker Collection, The Walter Crane Archive. Houghton Library, Harvard University, Cambridge, MA; **34** *Grammar in Rhyme*, London: George Routledge & Sons, 1868; **35l** *Annie and Jack in London*, London: George Routledge & Sons, 1869; **35r** Courtesy the Whitworth, The University of Manchester; **36** *The Song of Sixpence Picture Book*, London: John Lane, 1909; **37** *A Gaping-Wide-Mouth-Waddling Frog*, London: George Routledge & Sons, 1866; **38l** *The Buckle My Shoe Picture Book*, London: John Lane, 1910; **38r** *The Fairy Ship*, London: George Routledge & Sons, 1870; **39l, 39r** Walter Crane, *An Artist's Reminiscences*, London: Methuen & Co., 1907; **40, 41** The Osborne Collection of Early Children's Books, Toronto Public Library; **42** Metropolitan Museum of Art, New York. Gift of Mr and Mrs Bryan Holme, 1982 (1982.1125.2); **43, 44, 45, 46** *Walter Crane's Picture Books*, Vols 2–5, London: John Lane, 1897–99; **48–49, 50, 51** Beinecke Library, Yale University, New Haven, CT; **52a** *The Yellow Dwarf*, London: George Routledge & Sons, 1875; **52b** *Princess Belle-Etoile*, London: George Routledge & Sons, 1875; **53** Beinecke Library, Yale University, New Haven, CT; **54** Tempera on paper, 71.1 × 40.6 (28 × 16). Leeds Museums and Galleries (Leeds Art Gallery)/Bridgeman Images; **56–57** Beinecke Library, Yale University, New Haven, CT; **58** The Caroline Miller Parker Collection, The Walter Crane Archive. Houghton Library, Harvard University, Cambridge, MA; **59** British Museum, London; **60, 61l** Victoria and Albert Museum, London; **61r** Clarence Cook, *The House Beautiful*, New York: Scribner, Armstrong & Co., 1878; **62, 63** *Walter Crane's Picture Books*, Vols 2 & 5, London: John Lane, 1897, 1899; **64l,**

64r *Walter Crane's Picture Book*, London: Frederick Warne & Co., 1900; **65l** Tempera, gouache and oil on card and canvas, 119 × 98 (46⅞ × 38⅝). Kunsthalle Hamburg. Photo Art Collection 2/Alamy Stock Photo; **65r** *Walter Crane's Picture Book*, London: Frederick Warne & Co., 1900; **66–67** Collection of Roger Thorp; **68** *The Buckle My Shoe Picture Book*, London: John Lane, 1910; **70** The Caroline Miller Parker Collection, The Walter Crane Archive. Houghton Library, Harvard University, Cambridge, MA; **71al** Courtesy the Whitworth, The University of Manchester; **71ar** The Caroline Miller Parker Collection, The Walter Crane Archive. Houghton Library, Harvard University, Cambridge, MA; **71b** *Mr Michael Mouse Unfolds his Tale*, New Haven: Yale University Library, 1956; **72** J. M. D. Meiklejohn, *The Golden Primer*, London & Edinburgh: William Blackwood & Sons, 1884; **73** Walter Crane Collection, Camberwell College of Arts Library, University of the Arts London. Image courtesy University of the Arts London; **74** Beinecke Library, Yale University, New Haven, CT; **75** Mrs Molesworth, *Christmas-Tree Land*, London: Macmillan & Co., 1884; **76a** Mary de Morgan, *The Necklace of Princess Fiorimonde and Other Stories*, London: Macmillan & Co., 1886; **76b** Lucy Crane, *Art and the Formation of Taste*, London: Macmillan & Co., 1882; **77** Collection of Roger Thorp; **79** Walter Crane Collection, Camberwell College of Arts Library, University of the Arts London. Image courtesy University of the Arts London; **80a** Oil and tempera on canvas, 122.5 × 267 (48¼ × 105⅛). Christie's Images, London/Scala, Florence; **80b** Beinecke Library, Yale University, New Haven, CT; **81** *Walter Crane's Picture Books*, Vol. 5, London: John Lane, 1899; **83al** Getty Research Institute, J. Paul Getty Trust, Los Angeles, CA; **83ar** Private collection; **83b, 84l, 84r** Beinecke Library, Yale University, New Haven, CT; **85l** Walter Crane Collection, Camberwell College of Arts Library, University of the Arts London. Image courtesy University of the Arts London; **85r** Beinecke Library, Yale University, New Haven, CT; **86l, 86cl, 86cr, 86r** Collection of Roger Thorp; **87** Morgan Library & Museum, New York; **88** PJ Mode Collection of Persuasive Cartography. Division of Rare & Manuscript Collections, Cornell University Library, Ithaca, NY; **89l** G. Bernard Shaw (ed.), *Fabian Essays in Socialism*, London: The Fabian Society, 1889; **89r** Collection of Roger Thorp; **90** John Rylands Library, The University of Manchester Library; **91l, 91r, 92** Courtesy the Whitworth, The University of Manchester; **93** Collection of Roger Thorp; **94–95** Courtesy the Whitworth, The University of Manchester; **96** Private collection/Photo Ken Welsh/Bridgeman Images; **97** Oscar Wilde, *The Happy Prince and Other Tales*, London: D. Nutt, 1888; **98l** Private collection; **98r** *Columbia's Courtship*, Boston: Prang, 1893; **99** Nathaniel Hawthorne, *A Wonder Book for Girls & Boys*, Boston: Houghton Mifflin, 1892; **101** *Walter Crane's Picture Books*, Vol. 5, London: John Lane, 1899; **102** Walter Crane Collection, Camberwell College of Arts Library, University of the Arts London. Image courtesy University of the Arts London; **103l** Mary Macgregor, *The Story of Greece*, London & Edinburgh: T. C. & E. C. Jack, 1913; **103r** From Isobel Spencer, *Walter Crane*, London: Studio Vista, 1975, with courtesy to Mrs A. E. Clark-Kennedy; **104, 105** *Walter Crane's Picture Books*, Vol. 3, London: John Lane, 1897; **112** Courtesy John Rylands Library, The University of Manchester Library.

ACKNOWLEDGMENTS

I am proud to be part of this series and would like to thank Quentin Blake and Claudia Zeff as well as Roger Thorp, Julia MacKenzie and the team at Thames & Hudson for their enthusiasm and support. My thanks go to Carmen Callil for the gift of *Fabian Essays*, 1889, to Rosi Dodd for the loan of her Walter Crane Toy Books, and to Roger Thorp for Crane's

Socialist postcards and advertisements. I owe a great debt to all the archivists, and am particularly grateful to Gillian Forrester, formerly of the Whitworth Art Gallery, Leanne Green of the Whitworth, Stella Halkyard of the John Rylands Library, and to Francesca Tancini, who is currently preparing a catalogue raisonné of Crane's illustrated books.

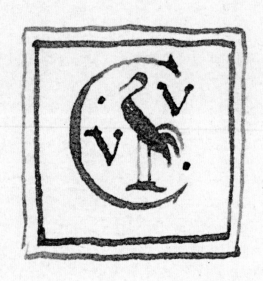